19th Century Ornament and Design
Ornements et motifs XIXᵉ siècle
Ornamente und Motive des 19. Jahrhunderts
Орнаменты и дизайн девятнадцатого века

Clara Schmidt

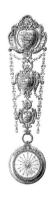

L'*Aventurine*

English: C.S.
Deutsch: Annett Richter
Russian: Julia Eveleva
© PCM, Lyon, 2007

• Contents • Sommaire • Inhalt •
• Índice • Содержание

Foreword

The 19th century definitely is the century of Decorative Arts. A profusion of styles develop, the advent of bourgeoisie leads to the creation of numerous pieces of art and furniture. Next to grandiose settings, the art of interior decoration and design is at the same time intimist and luxuriant . This proliferation can be seen in the Great Exhibitions, from 1851 at the Crystal Palace in London to the subsequent Universal Exhibitions. Increasing numbers of collections and compendiums of ornaments and patterns for the use of craftsmen are published.

This period in time constantly wavers between the search for modernity–principally in architecture, where new materials such as cast iron and steel are used, but also in the manufacturing of " industrial " objects–and the return to the past, driven by a universalist will according to which all cultures have an intrinsic value.

Archaeology and innovation combine to define styles which, although drawing on established records, have their specific life : Empire, Neo-Gothic, eclecticism…

The Empire style, inspired from Egyptian and Graeco-Roman antiquity, sees the triumph of classicism, with the introduction of columns topped by capitals ornated with acanthus leaves in architecture, furniture, and numerous everyday or decorative items… Palmettes, lotuses, eagles, lions, chimeras, crowns, torches and other trophies brought from Egypt, Pompeii or Herculaneum become widespread. Couches are copied from Roman table beds.

The Neo-Gothic style revives the mediaval world, with its ogives, its turrets, its floral and geometric-designs, while asserting a momentum to modernity and the desire of creating a " new art ".

Eclecticism is the prominent sign of the spirit of the time, combining medieval, Renaissance, Baroque and neoclassical elements.

Avant-propos

Le XIXe siècle est, à proprement parler, le siècle de l'art décoratif. Une profusion de styles se développent et l'avènement de la bourgeoisie provoque la création de nombreux objets d'art et pièces de mobilier. Ainsi, à côté de décors d'apparat grandioses, se développe un art de la décoration intérieure intimiste et exubérant à la fois. On peut voir ce foisonnement dans les expositions : celle du Crystal Palace, à Londres en 1851, puis les grandes Expositions universelles. D'autre part, les recueils d'ornements à l'usage des artisans, mais aussi de l'apprentissage du dessin se multiplient.

Cette période oscille constamment entre la recherche de la modernité – exprimée principalement dans l'architecture où l'on emploie de nouveaux matériaux tels que la fonte et l'acier, mais aussi dans la fabrication d'objets « industriels » – et le retour sur le passé, mû par une volonté universaliste selon laquelle toutes les cultures ont une valeur. L'archéologie et l'innovation se marient pour définir des styles qui, bien que puisant dans un répertoire déjà établi, ont leur vie propre : style Empire, néo-gothique, éclectisme…

Le style Empire, inspiré de l'antiquité égyptienne et gréco-romaine, voit triompher le classicisme avec l'introduction de colonnes surmontées de chapiteaux à feuille d'acanthes dans l'architecture, le mobilier, et aussi dans de nombreux objets usuels ou décoratifs. Les palmettes, lotus, aigles, lions, chimères, couronnes, flambeaux et autres trophées rapportés d'Égypte ou de Pompéi et Herculanum se répandent. Le trépied fait son apparition ainsi que le divan, calqué sur le modèle des lits de table romains.

Le style néo-gothique, ou revival, fait revivre le monde médiéval, avec ses ogives, ses tourelles et ses décors floraux géométriques, tout en affirmant un élan vers la modernité et le désir de créer un « art nouveau ».

L'éclectisme, quant à lui, est le signe marquant de l'esprit du temps, et mêle des éléments médiévaux, renaissance, baroques, et néo-classiques.

Vorwort

Das 19. Jahrhundert ist genau genommen das Jahrhundert der Dekorationskunst. Eine Fülle von Stilen entwickelt sich, und das Erstarken des Bürgertums beflügelt die Produktion von zahlreichen Kunstgegenständen und Möbelstücken. Neben den prunkvollen Kunstdekors entwickelt sich eine Innendekorationskunst, intim und zur Schau stellend zugleich. Man kann diese Fülle in den Ausstellungen bewundern wie jene im Kristall Palast in London im Jahre 1851 oder auch die der großen Weltausstellungen. Andererseits vervielfältigen sich die Sammlungen von Ornamenten zum Gebrauch von Kunsthandwerkern sowie zum Erlernen des Zeichnens.

Diese Periode schwankt stetig zwischen der Suche nach Modernität - hauptsächlich entwickelt im Architekturbereich durch den Gebrauch neuer Materialien wie von Gusseisen und Stahl, aber auch bei der Herstellung von industriellen Gegenständen - und die Rückwendung zur Vergangenheit, angetrieben durch einen universalen Willen auf Grund deren alle Kulturen einen Wert haben. Die Archäologie und Neuentwicklung treffen aufeinander, um Stile zu bestimmen, die, obwohl sie schon erfasst wurden, ihre eigene Bedeutung haben und ihr Eigenleben entwickeln: Stil Imperieur, Neu- Gotik, Kirchenkunst....

Der Empire Stil, vom ägyptischen und griechisch-römischen Altertum herkommend, sieht den Klassizismus triumphieren durch die Benutzung von Akanthusblattkapitellen umwundener Säulen in der Architekturkunst, sowie in dem Mobiliar und in anderen zahlreichen gebrauchs- oder dekorativen Gegenständen: Palmetten, Lotosblüten, Adler, Löwen, Schimären, Kronen, Fackeln und andere Trophäen, von Ägypten oder Pompéi und Herculanum abstammend, nehmen immer mehr zu. Der Dreifuss tritt in Erscheinung als auch der Divan, nachgeahmt römischen Tafelbetten.

Der neu- gotische oder auch "revivale" Stil lässt die mittelalterliche Welt mit seinen Köpfen, Türmchen und geometrischen Blumendekors wieder aufleben, in dem ein Impuls in Richtung auf die Modernität und das Verlangen, eine neuartige Kunst zu schaffen, aufgenommen wird..

Was die Kirchenkunst betrifft, so ist diese ein markantes Zeichen des Zeitgeistes. und sie vermischt mittelalterliche Elemente mit denen der Renaissance, des Barock und des Neo-Klassizismus.

Предисловие

19 столетие стало веком Декоративного искусства. Получили распространение разнообразные декоративные стили, а появление буржуазии привело к созданию многочисленных произведений искусства и предметов мебели. На фоне эффектной обстановки особое внимание привлекают предметы внутреннего убранства с их великолепием и простотой. Многие из них можно было увидеть на Всемирных выставках, начиная с 1851 года в Хрустальном дворце, и далее на Международных выставках. Издавались различные сборники орнаментов и узоров для применения в разнообразных сферах и ремеслах. В этот период мастера архитектуры пребывают в поисках средств выражения современных стилей с использованием новых материалов, таких, как чугун и сталь, одновременно стремясь создавать промышленные изделия. В то же время их привлекают стили прошлого, под влиянием течения универсализма, согласно которому все культуры имеют внутреннюю ценность.

Археологические исследования в сочетании с новыми подходами определили стили, которые хотя и основывались на устоявшихся традициях, но несли в себе новые начала: ампир, неоготика, эклектика...

Стиль ампир, появившийся под влиянием египетской и греко-римской античности, провозгласил триумф классицизма, добавив в него колонны, увенчанные капителями с листьями аканта, в архитектуре, мебельной промышленности и всевозможных повседневных и декоративных предметах внутреннего убранства... Всемирную популярность приобрели пальметки, лотосы, орлы, львы, химеры, короны, факелы и другие трофеи, привезенные из Египта, Помпей и Геркуланума. В диванах и кушетках можно проследить стиль римских прикроватных столиков.

Неоготика вносит новые черты в средневековое искусство с его стрельчатыми сводами, башенками, цветочными и геометрическими узорами, в то же время отмечая момент перехода к модернизму и созданию «нового искусства».

Эклектика стала важной вехой своего времени, сочетая в себе элементы средневекового стиля, ренессанса, барокко и неоклассицизма.

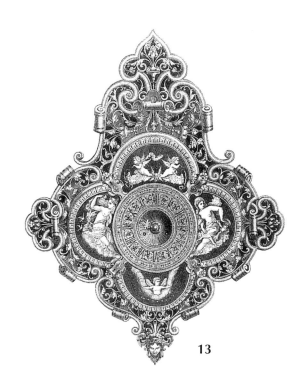

13

• Domestic objects •
• Objets domestiques •
• Hausgegenstände •
• Предметы домашнего обихода •

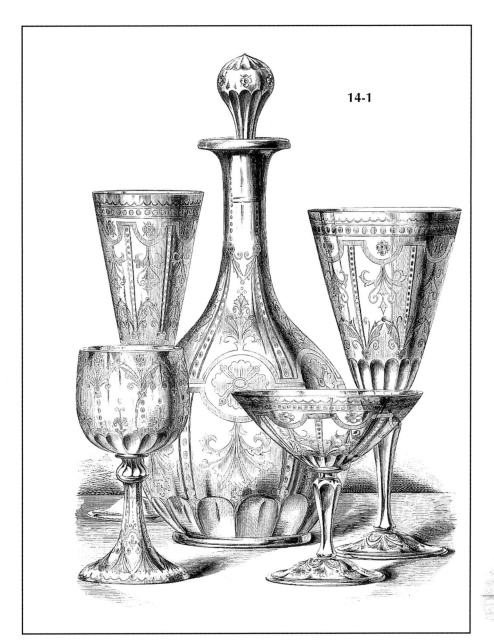

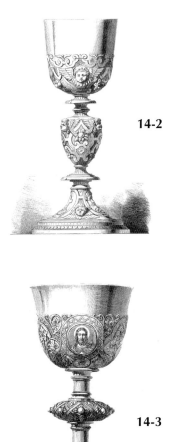

13:

F. Barbedienne. Enamelled bronze and inlayed silver clock, silver and black lacquered face, France, 1876.

F. Barbedienne. Horloge en bronze émaillé et marqueté d'argent, cadran en argent et laqué noir. France, 1876.

F. Barbedienne. Uhr mit emaillierter Bonze und Silberintarsien, silbernem Zifferblatt und schwarz lackiert. Frankreich, 1876.

Ф. Барбедьен. Часы - бронза, серебро, эмаль, нкрустация. Циферблат — серебро, черный лак. Франция, 1876.

14:

Crystalware and gold plate.
Cristallerie et orfèvrerie.
Kristallfabrikation und Goldschmiedekunst.
Изделия из хрусталя и золота.

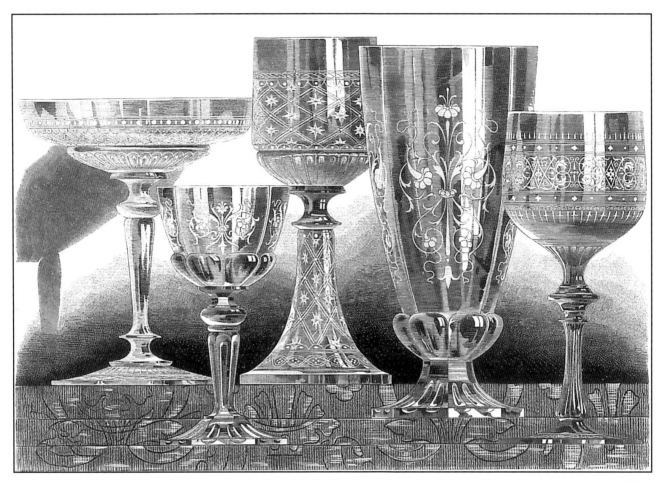

J. & L. Lobmeyr. Engraved crystal glasses, Vienna, 1878.
J&L Lobmeyr. Verres en cristal ciselé et gravé. Vienne, 1878.
J&L Lobmeyr. Kristallgläser, geschliffen und graviert, Wien, 1878.
Дж. и Л. Лобмейр. Бокалы, хрусталь, гравировка, Вена, 1878.

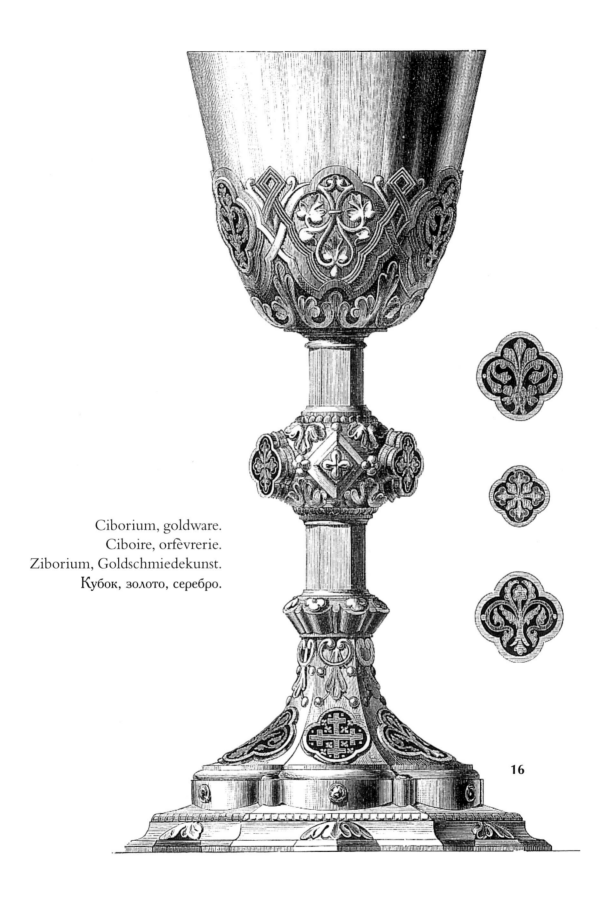

Ciborium, goldware.
Ciboire, orfèvrerie.
Ziborium, Goldschmiedekunst.
Кубок, золото, серебро.

16

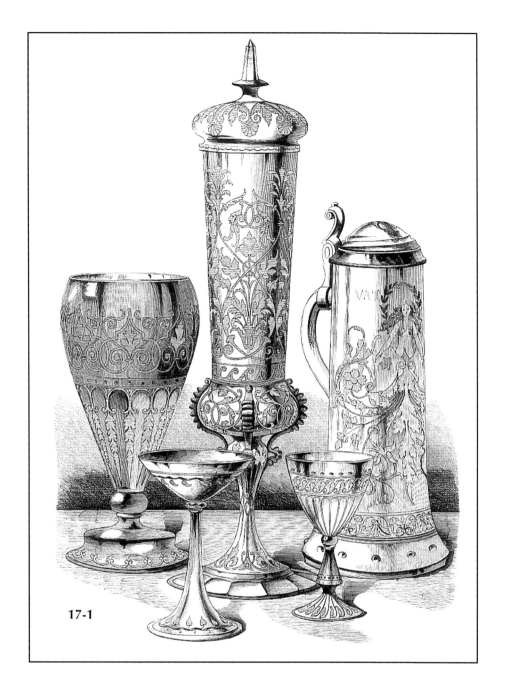

17-1

17-2

17-3

17:
Crystal and gold wares.
Cristallerie et orfèvrerie.
Kristallfabrikation und Goldschmiedekunst.
Изделия из хрусталя и золота.

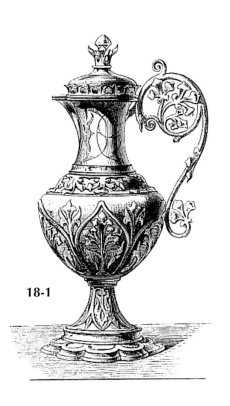

18-1

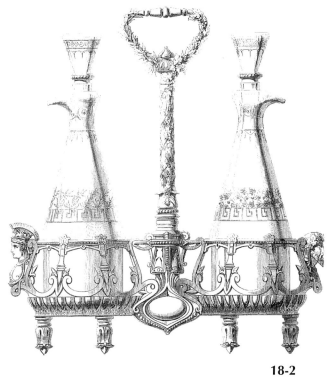

18-2

18-2, 18-3:
Oil and vinegar sets.
Huiliers et vinaigriers.
Ölständer und Essiggefäße.
Посуда для масла и уксуса.

18-1, 19:
Ewers.
Aiguières.
Wassergefäße.
Кувшины.

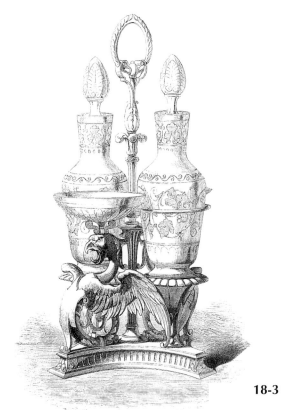

18-3

18

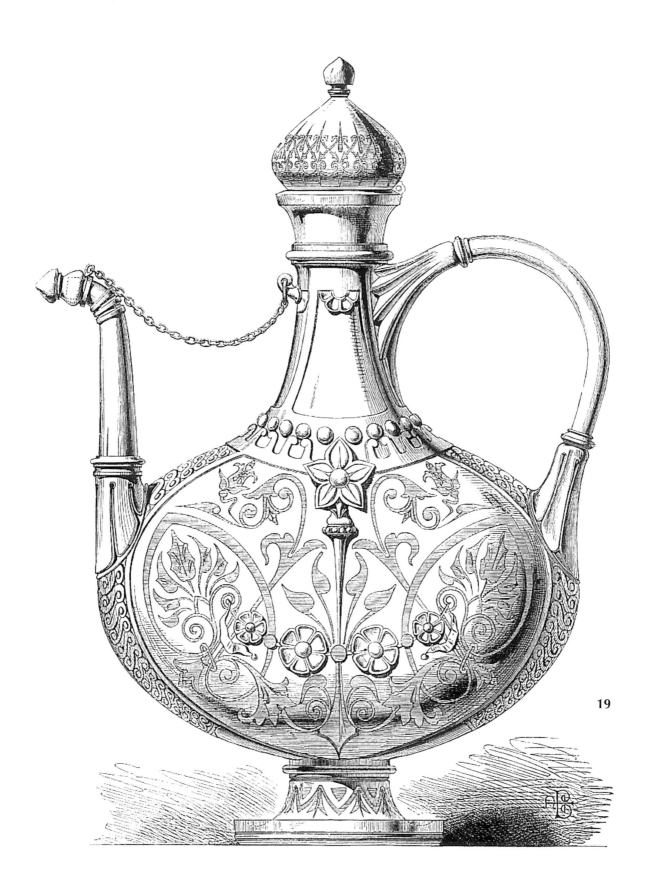

19

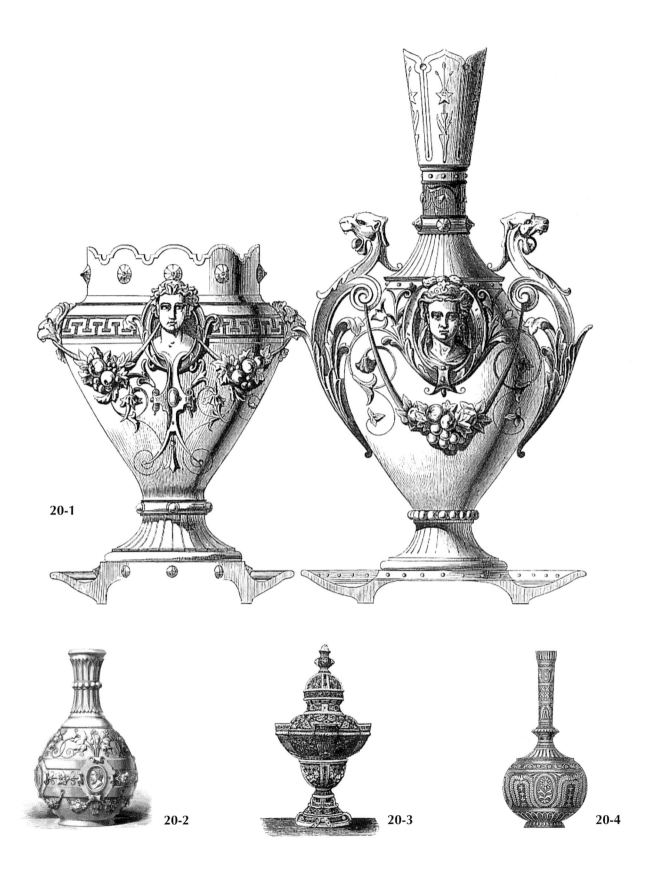

20-1

20-2

20-3

20-4

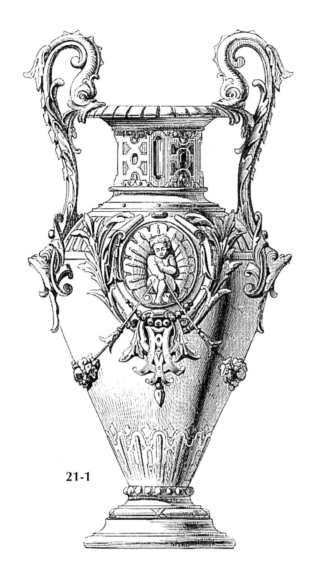

21-1

20-21:
Decorative vases, ceramic, majolica and china.
Vases ornementaux, céramique, majolique et porcelaine.
Verzierte Vasen, Keramiken und Porzellan, majolicker Herkunft.
Декоративные вазы из керамики, майолики и фарфора.

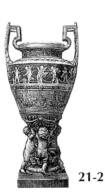

21-2

21-3

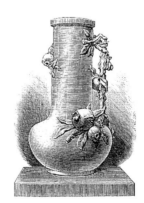

21-4

22-1

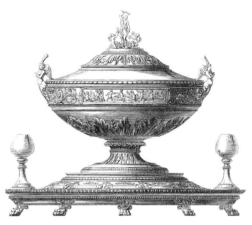

22-2

22-3

22:
Goldware.
Orfèvrerie.
Goldschmiedekunst.
Изделия из золота.

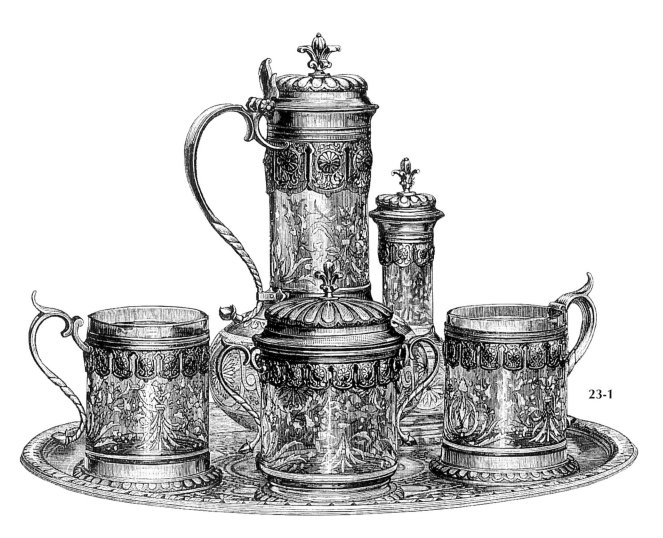

23-1

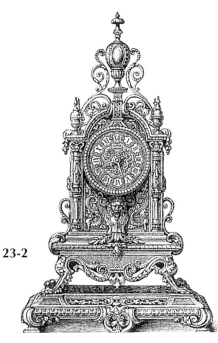

23-2

23-1:
Christofle. Set of glasses, enamelled Bohemian crystal, France, 1878.
Christofle. Service de verres en cristal de Bohème émaillé. France,1878.
Christofle. Glasservice, émalliertes Kristall aus Böhmen, Frankreich, 1878.
Кристофль. Набор бокалов, богемский хрусталь, эмаль. Франция, 1878.

23-2:
Clock, bronze, Henri II style, France, 1890.
Horloge en bronze de style Henri II. France,1890.
Bronzeuhr aus der Zeit Henri II., Frankreich, 1890.
Часы из бронзы в стиле эпохи Ге́нриха II, Франция, 1890.

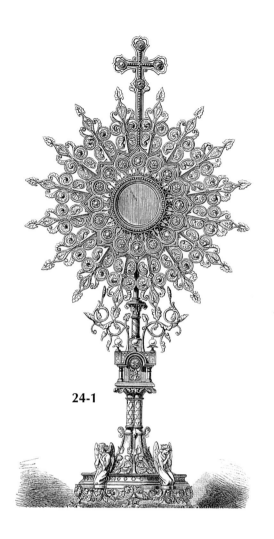

24-1

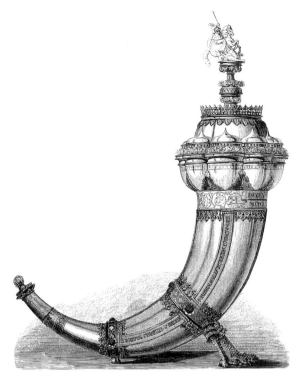

24-2

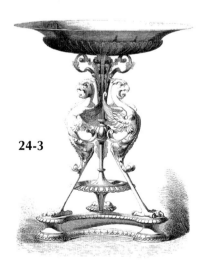

24-3

24–25:
Gold and silver ware.
Orfèvrerie et argenterie.
Goldschmiede- und Silberkunst.
Изделия из золота и серебра.

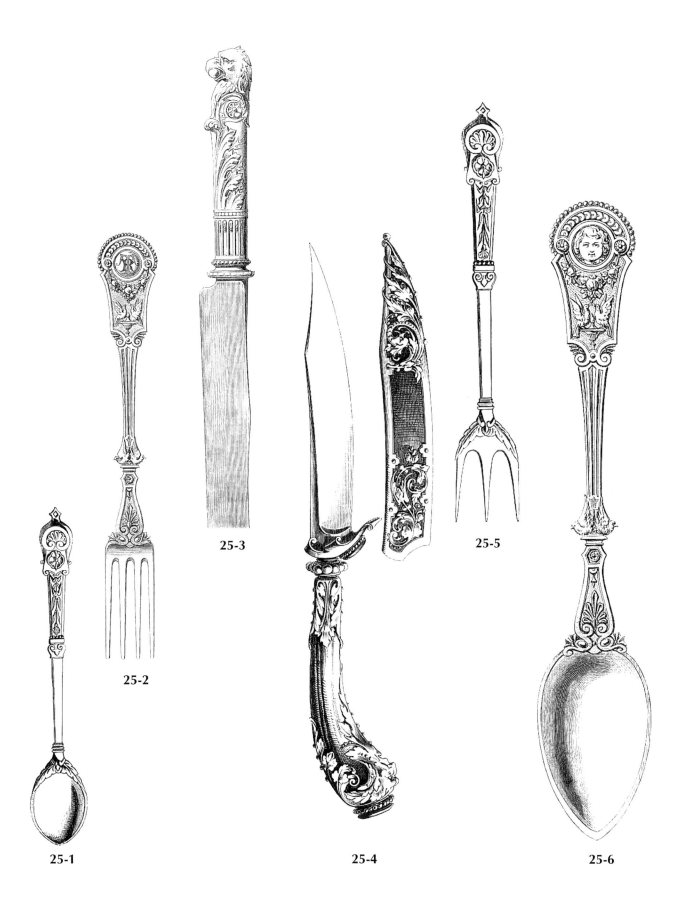

25-1

25-2

25-3

25-4

25-5

25-6

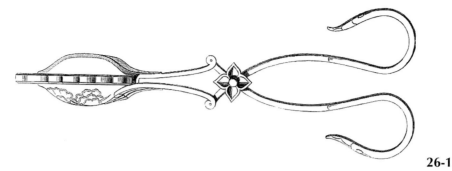

26-1

26-2

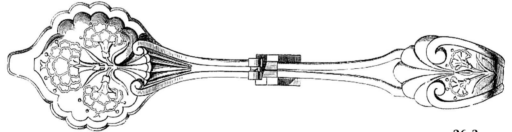

26-3

26:
Sugar bowl and sugar tongs, silverware.
Sucrier et pince à sucre en argenterie.
Zuckerzangen und Pinzette aus Silber.
Сахарница и щипцы для сахара, серебро.

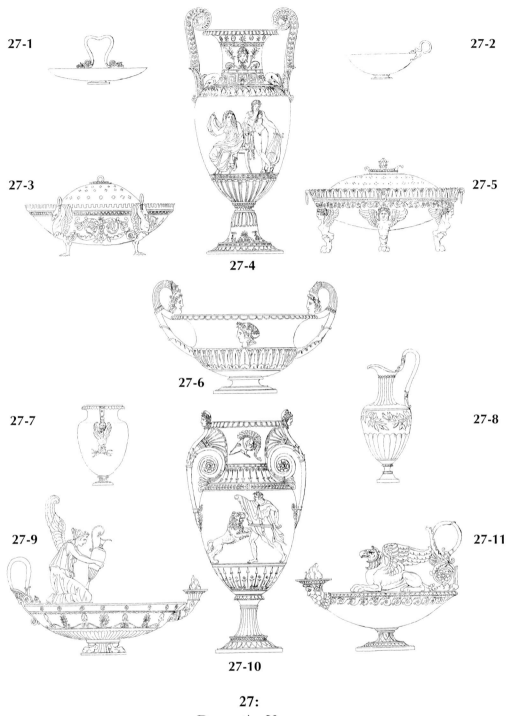

27-1

27-2

27-3

27-5

27-4

27-6

27-7

27-8

27-9

27-11

27-10

27:
Decorative Vases.
Vases décoratifs.
Dekorierte Vasen.
Декоративные вазы.

Percier et Fontaine. *Recueil de décorations intérieures*, Paris, 1801.

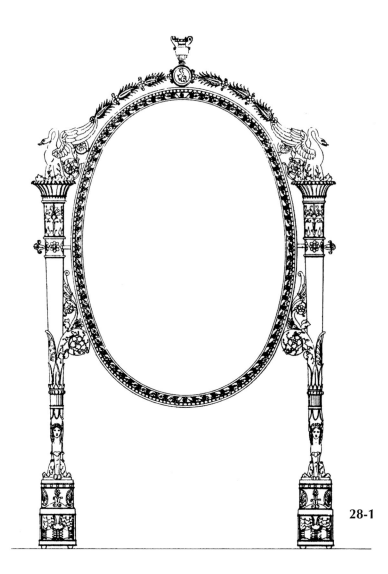

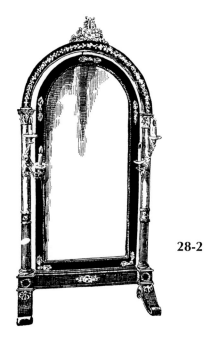

28-2

28-1

28-1, 28-2:
Mirrors.
Miroir.
Spiegel.
Зеркала.

29-1:
Tureen, silver and vermeil.
Soupière, argent et en vermeil.
Suppenschüssel, Silber und Vermeil.
Супница, серебро, золоченая бронза.

29-2, 29-3:
Vases, silver and vermeil.
Vases, argent et en vermeil.
Vasen, Silber und Vermeil.
Вазы, серебро, золоченая бронза.

29-4:
Coffee fountain, silver and vermeil.
Fontaine à café, argent et en vermeil.
Kaffeekanne, Silber und Vermeil.
Кофейница, серебро, золоченая бронза.

Percier et Fontaine. *Recueil de décorations intérieures*, Paris, 1801.

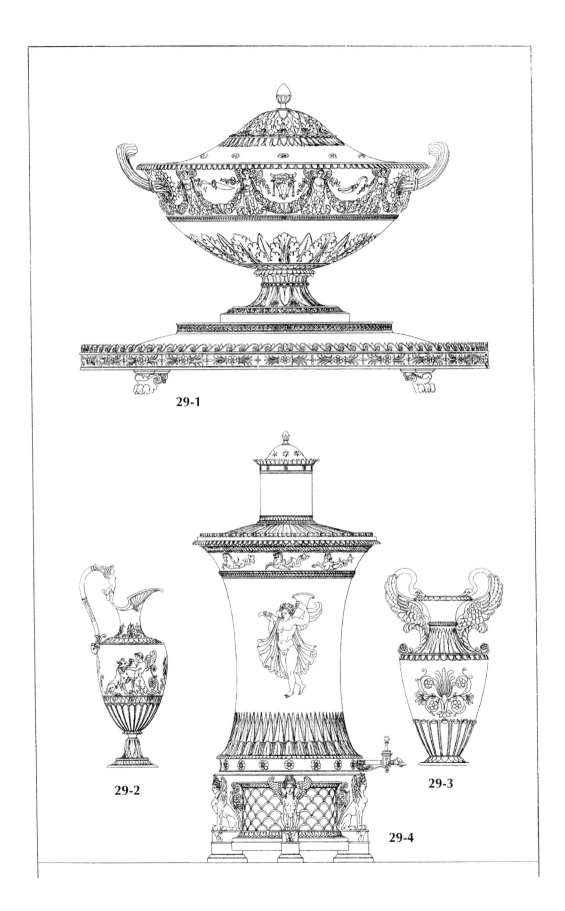

29-1

29-2

29-3

29-4

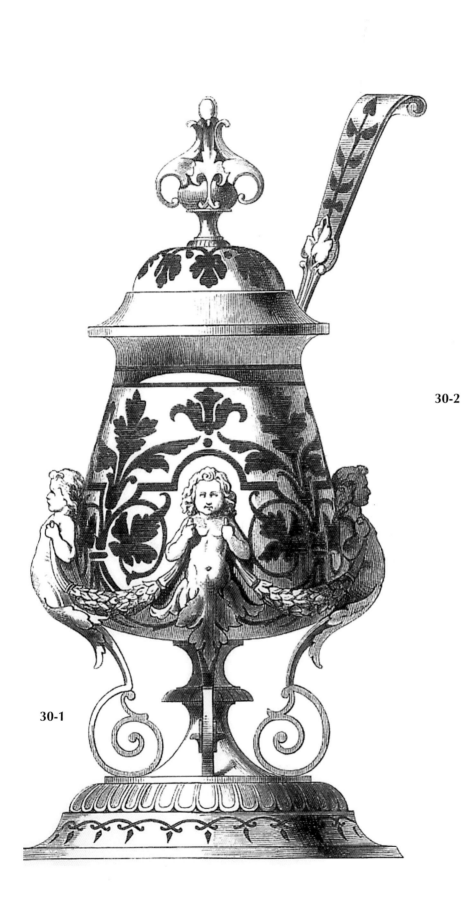

30-1

30-2

30-1:
Mustard pot, crystal and gilded silver, Italy, 1870.
Moutardier, argent ciselé et cristal. Italie, 1870.
Moutardier, graviertes Silber und Kristall. Italien, 1870.
Горчичница, хрусталь, серебро, золочение, Италия, 1870.

30-2:
Tongs and shovel, wrought iron, Italy, 1870.
Pince et pelle en fer forgé, Italie, 1870.
Pinzette und Schaufel für Kamine aus geschmiedetem Eisen, Italien, 1870.
Щипцы и лопатка, чугун, Италия, 1870.

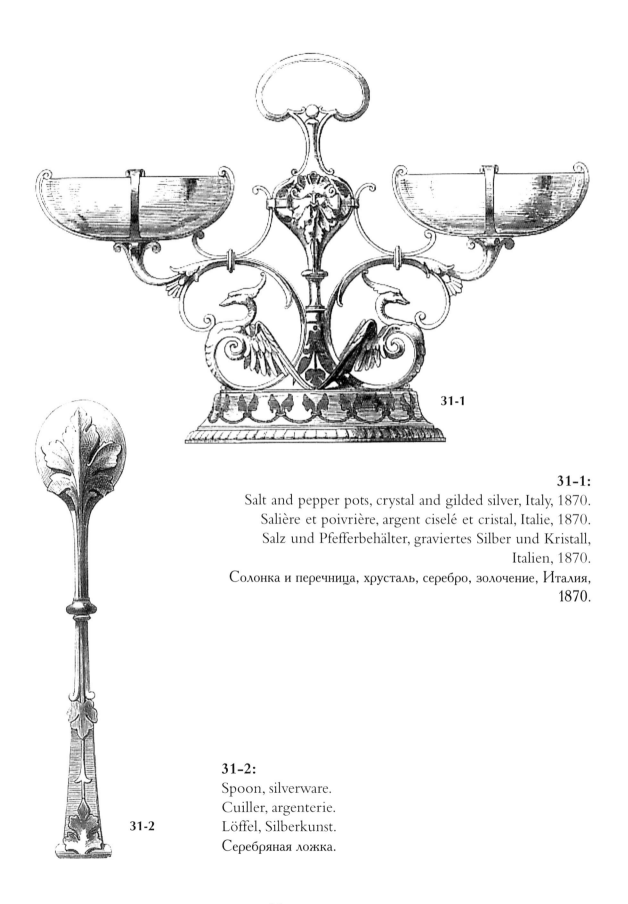

31-1

31-1:

Salt and pepper pots, crystal and gilded silver, Italy, 1870.

Salière et poivrière, argent ciselé et cristal, Italie, 1870.

Salz und Pfefferbehälter, graviertes Silber und Kristall, Italien, 1870.

Солонка и перечница, хрусталь, серебро, золочение, Италия, 1870.

31-2:

Spoon, silverware.

Cuiller, argenterie.

Löffel, Silberkunst.

Серебряная ложка.

31-2

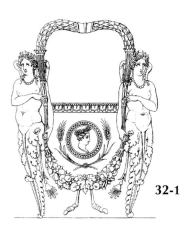

32-1

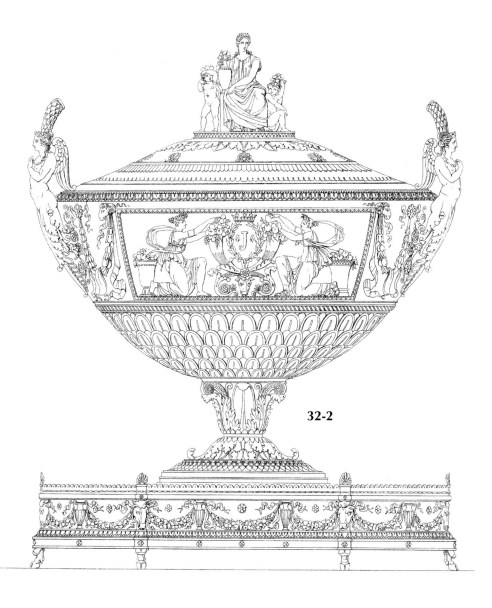

32-2

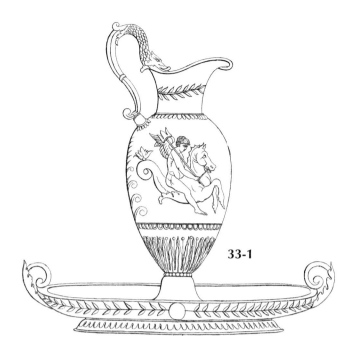

33-1

32–1:
Tureen, detail of handle, gold plate.
Soupière, détail d'une anse.
Супница, фрагмент ручки, листовое золото.

32–2:
Tureen, gold ware.
Soupière, orfévrerie.
Suppenschüssel, Goldschmiedekunst.
Супница, золото.

33:
Ewers.
Brocs.
Krüge.
Кувшины.

Percier et Fontaine. *Recueil de décorations intérieures*, Paris, 1801.

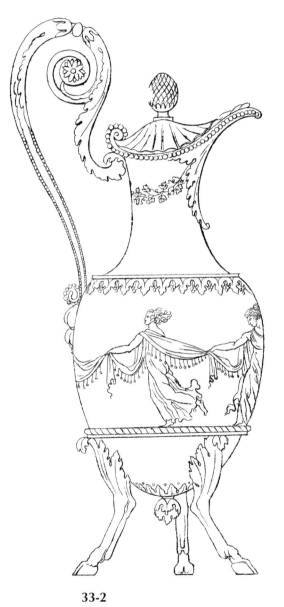

33-2

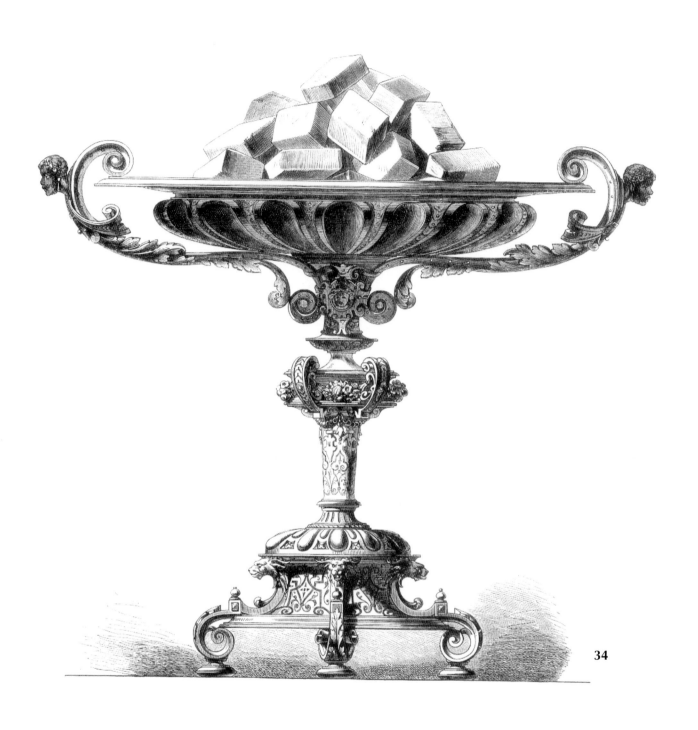

34

Sugar bowl, silverware.
Sucrier, argenterie.
Zuckerschale aus Silber.
Сахарница, серебро.

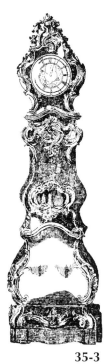

35-3

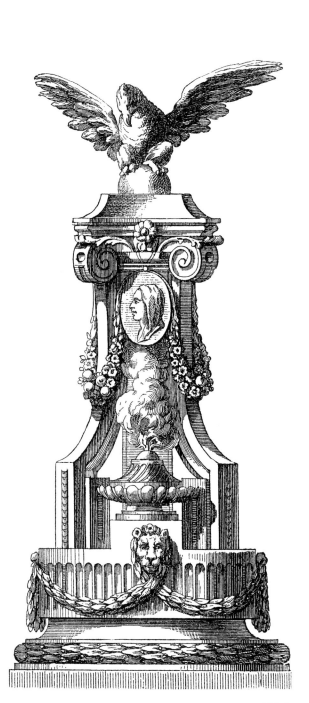

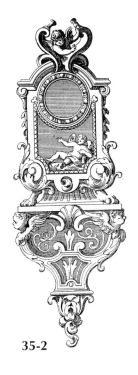

35-2

35-1, 36-1, 36-3:
Neoclassical stoves.
Poêles néoclassiques.
Neoklassische Öfen.
Печи, неоклассицизм.

35-2, 35-3, 36-2:
Neoclassical clocks.
Horloges néoclas-
siques.
Neoklassische Uhren.
Часы, неоклассицизм.

35-1

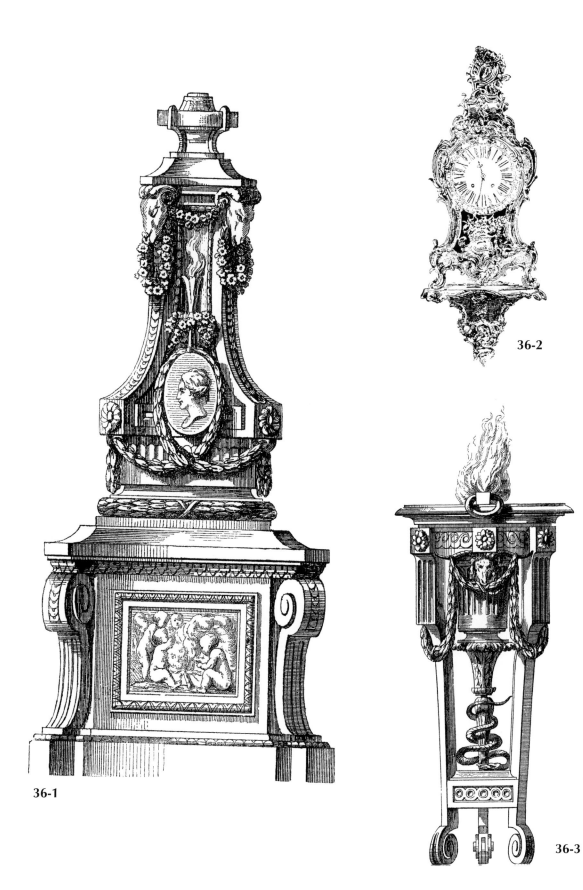

36-1

36-2

36-3

37-1

37-2

37-3

37-5

37-4

37–43:
Typographic vignettes.
Vignettes typographiques.
Typographische Vignetten.
Типографические виньетки.

38-1

38-4

38-2

38-3

38-5

 39-1

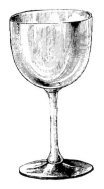 **39-2**

39-3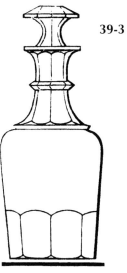

 39-4

39-6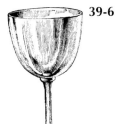

39-5

40-1

40-3

40-2

40-4

40-5

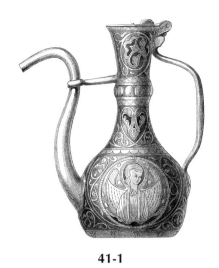

41-1

41-3

41-4

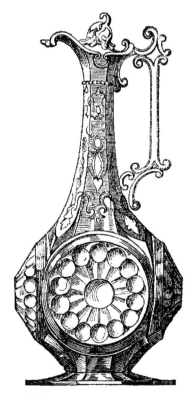

41-2

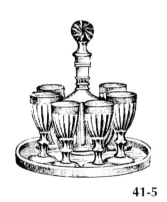

41-5

42-1

42-2

42-5

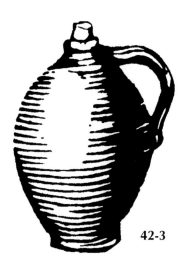

42-3

42-4

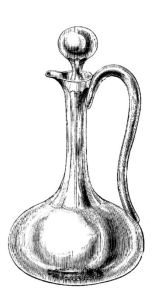

42-6

43-1

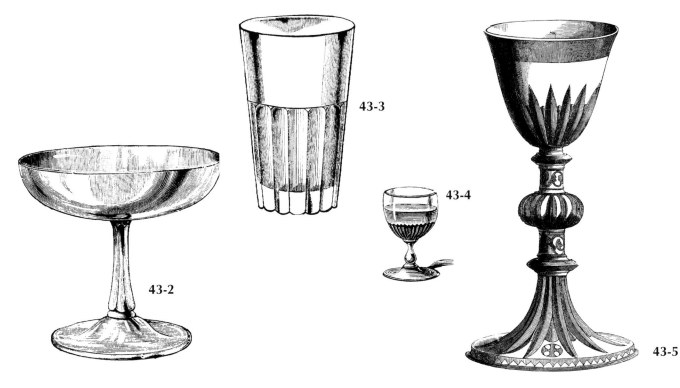

43-3

43-2

43-4

43-5

Fireguard, copper and
brass, 1870.
Pare-feu, cuivre
et laiton, 1870.
Feuerschutz, Kupfer
und Messing, 1870.
Каминная решетка,
медь, латунь, 1870.

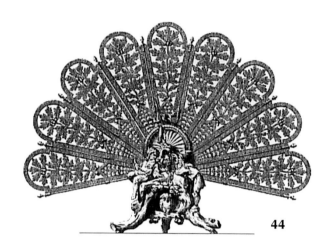

44

•Furniture •
• Mobilier •
• Mobiliar •
• Мебель •

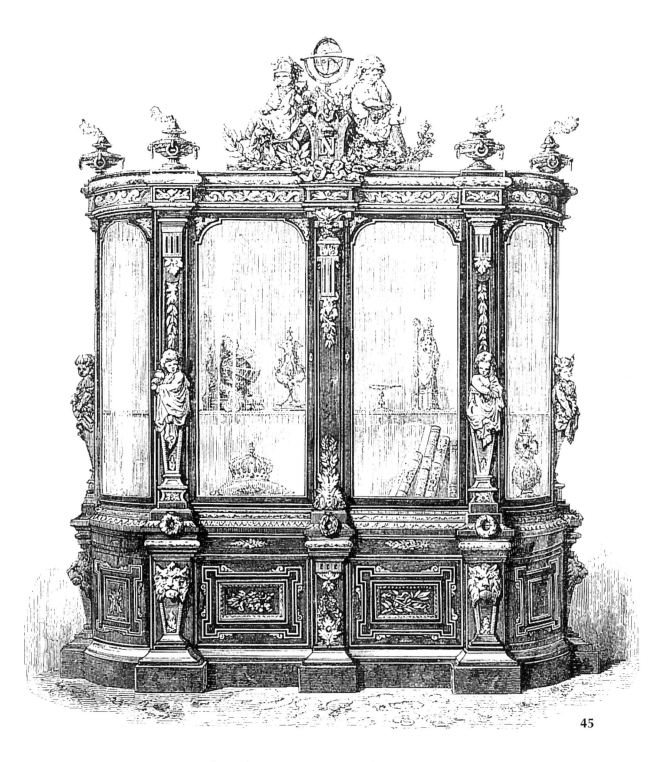

45

Display cabinet, Louis XVI style, France, 1870.
Vitrine de style Louis XVI, France, 1870.
Vitrine, Stil Louis XVI, Frankreich, 1870.
Сервант в стиле эпохи Людовика XVI, Франция, 1870.

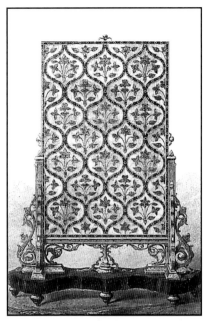

46-1

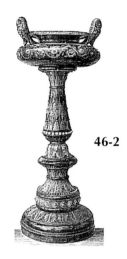

46-2

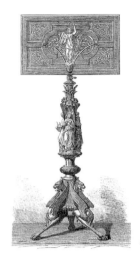

46-3

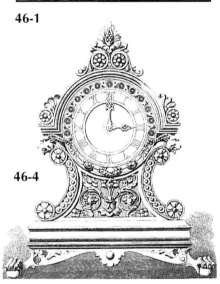

46-4

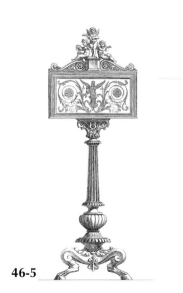

46-5

46-1:
Fireguard, gilded bronze and silk, France, 1876.
Pare-feu, bronze doré et soie, France, 1876.
Feuerschutz, vergoldete Bronze und Seide, Frankreich, 1876.
Каминная решетка, золоченая бронза, шелк, Франция, 1876.

46-2:
Plant holder, Doulton stoneware, England, 1878.
Jardinière, grès Doulton, Angleterre, 1878.
Gartenschmuck, Sandstein Doulton, England, 1878.
Растениедержатель, Доултонская керамика, Англия, 1878.

46-3:
Lectern, ebony and bronze, 1870.
Pupitre, ébène et bronze, 1870.
Notenständer, Ebenholz und Bronze, 1870.
Аналой, черное дерево, бронза, 1870.

46-4:
Clock, Italy, 1870.
Horloge, Italie, 1870.
Uhr, Italien, 1870.
Часы, Италия, 1870.

46-5:
Lectern, inlaid walnut, 1870.
Pupitre, noyer marqueté, 1870.
Notenständer, Walnussbaumholz mit Intarsien, 1870.
Аналой, грецкий орех, мозаика/инкрустация, 1870.

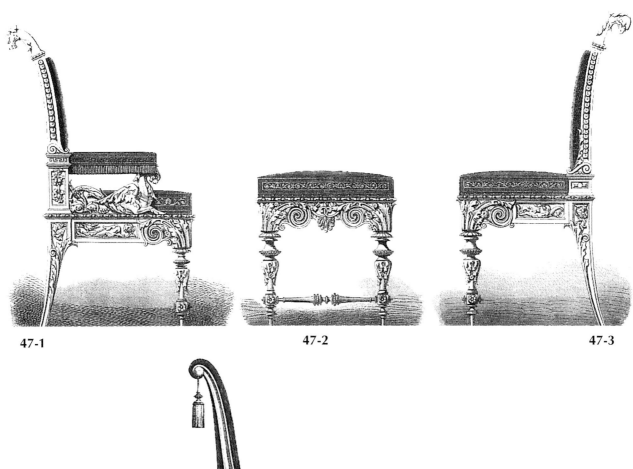

47-1 47-2 47-3

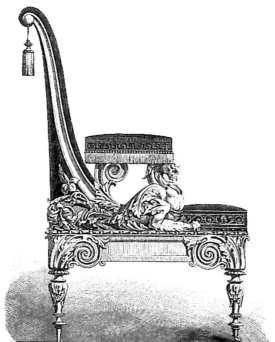

47-4

47:
Living-room furniture, 1870.
Mobilier de salon, 1870.
Salonmöbel, 1870.
Мебель для гостиной, 1870.

48-1:

Chaise longue, Louis XV style.
Chaise longue de style Louis XV.
Chaise longue, Stil Louis XV.
Шезлонг в стиле эпохи Людовика XV.

48-2:

Padded sofa, 1870.
Canapé matelassé, 1870.
Gestepptes Sofa, 1870.
Обитая софа, 1870.

48-3:

Armchair, 1870.
Fauteuil, 1870.
Sessel, 1870.
Кресло, 1870.

48-4:

Chair, armchair and small table, 1870.
Siège, fauteuil et petite table, 1870.
Stuhl, Sessel und kleiner Tisch, 1870.
Стул, кресло и небольшой столик, 1870.

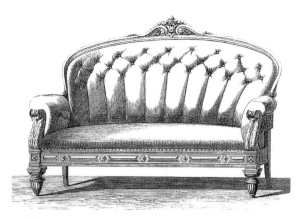

48-2

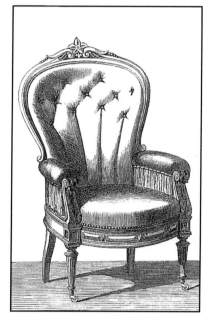

48-3

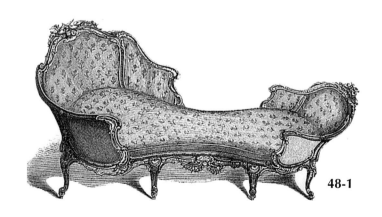

48-1

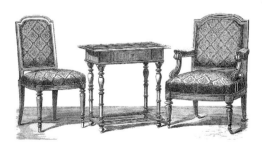

48-4

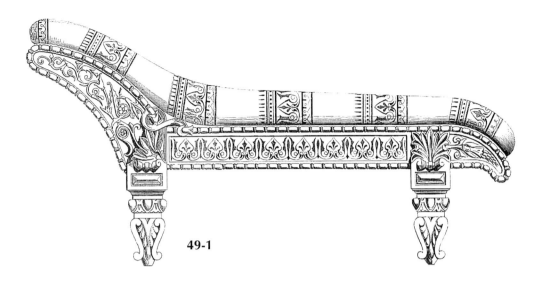

49-1

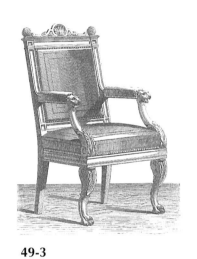

49-3

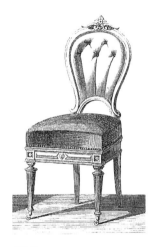

49-2

49-1:
Couch, Empire style.
Divan, style Empire.
Divan, Empire Stil.
Диван в стиле эпохи
правления Наполеона.

49-2:
Padded chair, 1870.
Siège matelassé, 1870.
Gepolsterter Stuhl, 1870.
Обитый стул, 1870.

49-3:
Armchair, 1870.
Fauteuil, 1870.
Stuhl, 1870.
Кресло, 1870.

49-4:
Sofa, Louis XV style.
Canapé, style Louis XV.
Canapé, Stil Louis XV.
Софа в стил эпохи Софа в
стиле эпохи Людовика XV.

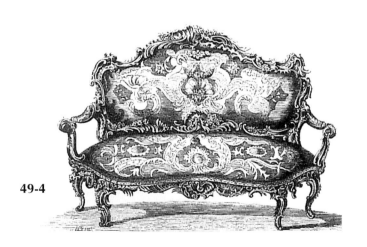

49-4

50-1:

Padded chair, Renaissance style, 1870.
Chaise matelassée de style Renaissance, 1870.
Gepolsterter Stuhl, Renaissance Stil, 1870.
Обитый стул, стиль Ренессанс, 1870.

50-2:

Padded chair, 1870.
Chaise matelassée, 1870.
Gepolsterter Stuhl, 1870.
Обитый стул, 1870.

50-3:

Chair, armchair and occasional table, 1870.
Chaise, fauteuil et guéridon, 1870.
Stuhl, Sessel und kleiner Tisch, 1870.
Стул, кресло и журнальный столик, 1870.

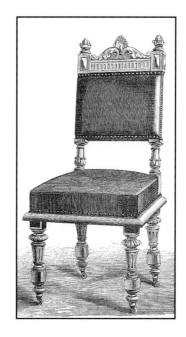

50-1

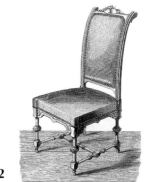

50-2

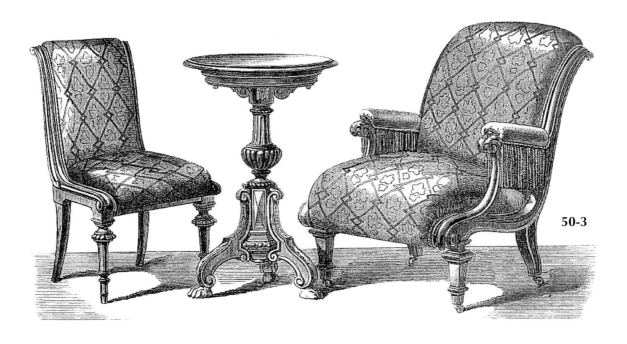

50-3

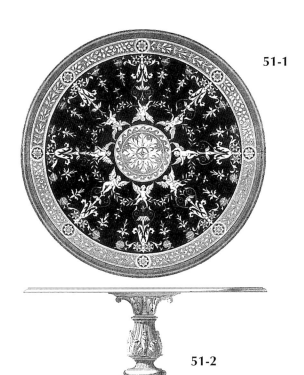

51-1

51-1, 51-2:
Table, inlaid walnut, 1870.
Table avec plaque en noyer marqueté, 1870.
Tischplatte aus Walnussbaumholz mit Intarsien, 1870.
Стол, грецкий орех, мозаика/инкрустация, 1870.

51-3, 51-4:
Tables, 1870.
Tables, 1870.
Tische, 1870.
Столы, 1870.

51-2

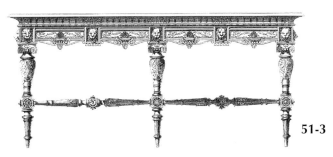

51-3

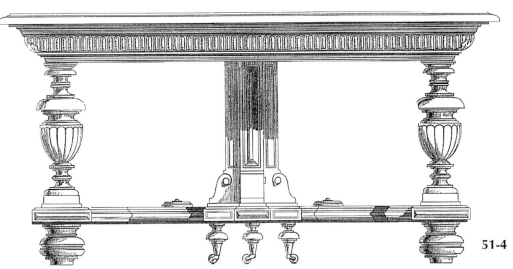

51-4

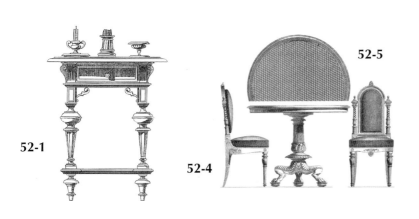

52-1

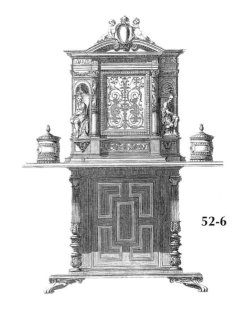

52-5

52-4

52-6

52-2

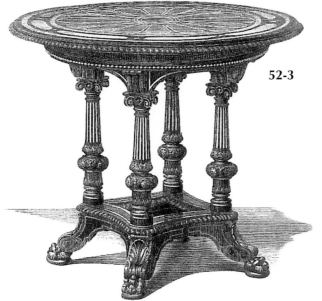

52-3

52-1:
Small table for smoking room, 1870.
Petite table pour fumoir, 1870.
Kleiner Tisch für Raucherzimmer, 1870.
Небольшой столик для курительной комнаты,
1870.

52-2, 52-3:
Table, inlaid walnut, Vienna, 1876.
Table, noyer marqueté, Vienne, 1876.
Tisch aus Walnussbaumholz mit Intarsien,
Wien, 1876.
Стол, грецкий орех, мозаика/инкрустация,
Вена, 1876.

52-4, 52-5:
Padded chairs and table, 1870.
Table et chaises matelassée, 1870.
Tisch und gepolsterte Stühle, 1870.
Обитые стулья и столик, 1870.

52-6:
Smoking room credenza, 1870.
Crédence pour fumoir, 1870.
Kredenz für Raucherzimmer, 1870.
Низкий шкаф для курительной комнаты, 1870.

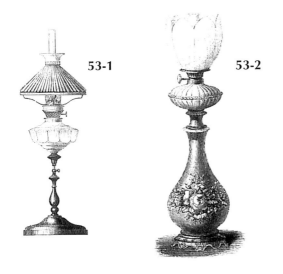

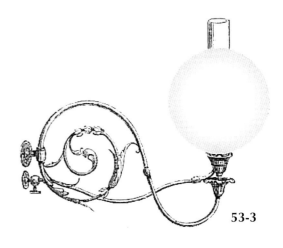

53-1, 53-2;
Paraffin lamps, second half of 19th century.
Lampes à pétrole, deuxième moitié du XIX^e siècle.
Öllampen, zweiter Hälfte des XIX. Jahrhunderts.
Керосиновые лампы, вторая половина 19 в.

53-3:
Electric lamp, 1880.
Lampe électrique, 1880.
Elektrische Lampe, 1880.
Электрическая лампа, 1880.

53-4:
Chandelier, 1870.
Lustre, 1870.
Kronleuchter, 1870.
Канделябр, 1870.

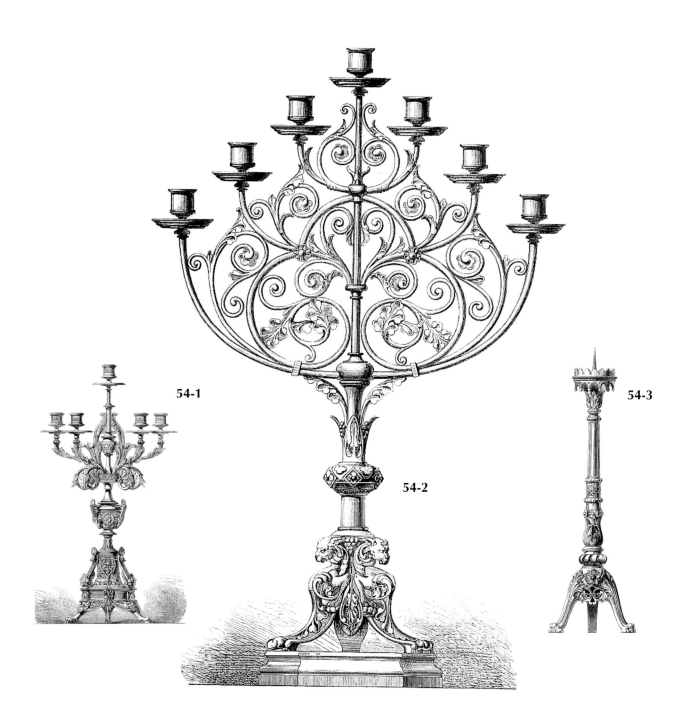

54-1

54-2

54-3

54:
Candelabra.
Candélabres.
Kandelaber.
Канделябры.

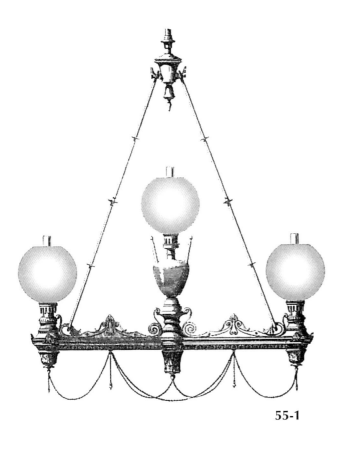

55-1

55-1:
Chandelier, 1870.
Lampadaire, 1870.
Leuchte, 1870.
Канделябр, 1870.

55-2:
Candelabrum.
Candélabre.
Kandelaber.
Канделябр.

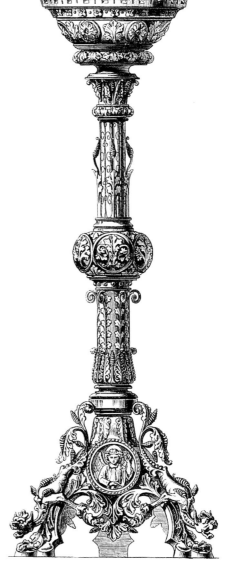

55-2

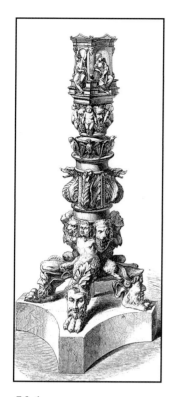

56-1

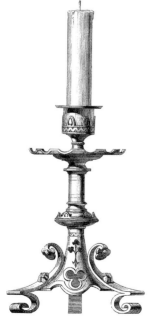

56-2

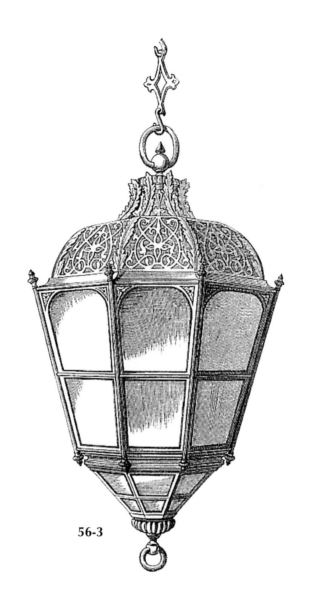

56-3

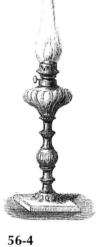

56-4

56-1:
Base of candelabrum.
Pied de candélabre.
Fuß eines Kandelabers.
Основание канделябра.

56-2:
Candlestick.
Chandelier.
Kerzenständer.
Подсвечник.

56-3:
Lantern.
Lanterne.
Laterne.
Фонарь.

56-4:
Paraffin lamp, second half of
19th century.
Lampe à pétrole, 2ᵉ moitié du
XIXᵉ siècle.
Öllampe , 2. Hälfte des xix.
Jahrhunderts.
Керосиновая лампа, вторая
половина 19 в.

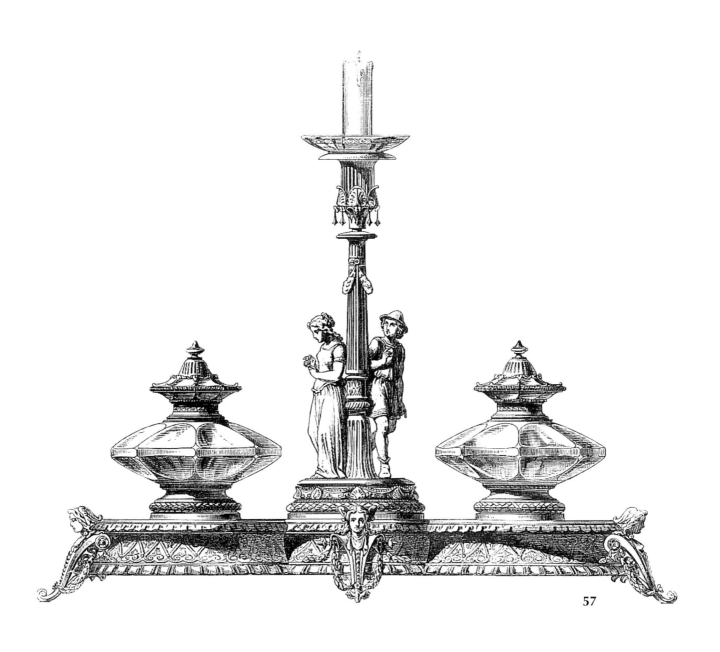

57

Candlestick-inkstand.
Bougeoir-encrier.
Kerzenständer mit aufgesetzten Tintenfässern.
Подсвечник-чернильница.

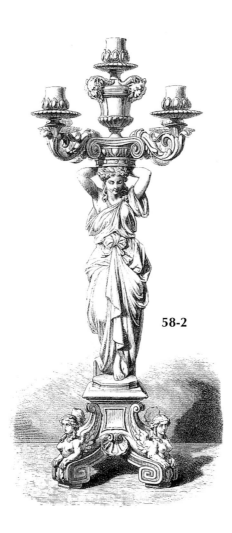

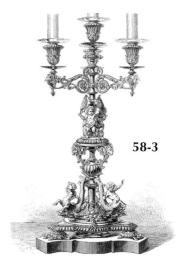

58-3

58-2

58-1

58-1,
Candlestick.
Candélabre.
Kerzenständer.
Подсвечник.

58-4

58-2, 58-3:
Candelabra.
Chandeliers.
Kerzenständer.
Канделябры.

58-4:
Ferdinando Romanelli. Candelabrum, carved wood, Italy, 1877.
Ferdinando Romanelli. Candélabre, bois sculpté, Italie, 1877.
Ferdinando Romanelli. Kerzenständer, skulptiertes Holz, Italien, 1877.
Фердинандо Романелли. Канделябр, резьба по дереву, Италия, 1877.

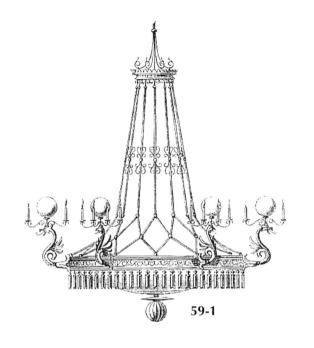

59-1

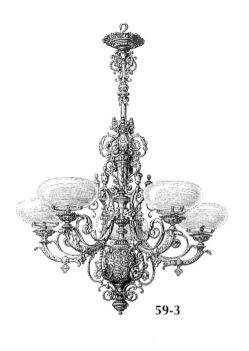

59-3

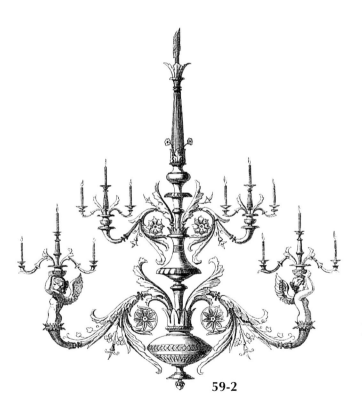

59-2

59-1:
Chandelier , 1870.
Lustre, 1870.
Kronleuchter, 1870.
Канделябр, 1870.

59-2:
Chandelier, Renaissance style,
1870.
Lustre, style Renaissance, 1870.
Kronleuchter, Renaissance Stil,
1870.
Канделябр, стиль Ренессанс, 1870.

59-3:
Chandelier , bronze, Germany,
1890.
Lustre en bronze, Allemagne, 1890.
Kronleuchter aus Bronze,
Deutschland, 1890.
Бронзовый канделябр, Германия,
1890.

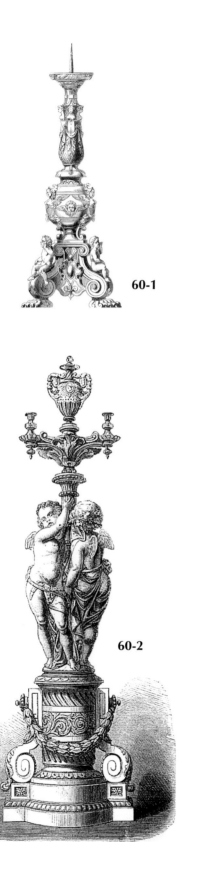

60-1

60-3

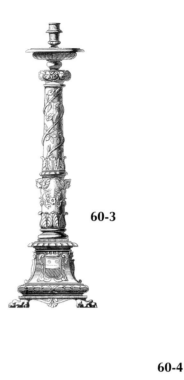

60-4

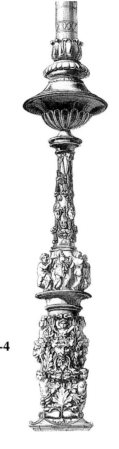

60-2

60-1, 60-3, 60-4:
Candelabra.
Candélabres.
Kerzenständer.
Канделябры.

60-2:
Candelabrum, engraved silver, Italy, 1876.
Candelabre, argent ciselé, Italie, 1876.
Kerzenständer aus graviertem Silber, Italien,
1876.
Канделябр, серебро, гравировка, Италия,
1876.

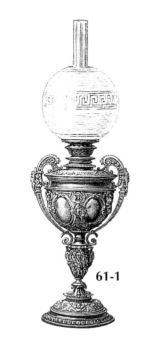

61-1

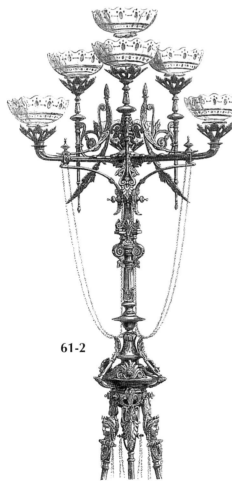

61-2

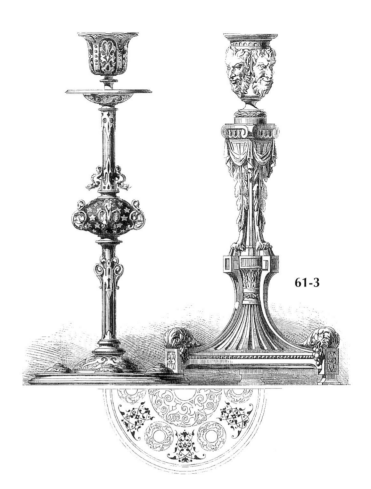

61-3

61-1:
Hugo Stotz. Lamp, bronze, Germany, 1890.
Hugo Stotz. Lampe, bronze, Allemagne, 1890.
Hugo Stotz. Lampe, Bronze, Deutschland, 1890.
Хуго Штотц. Бронзовая лампа, Германия, 1890.

61-2:
Candelabrum, bronze, Fance, 1877.
Candelabre, bronze, France, 1877.
Kerzenständer, Bronze, Frankreich, 1877.
Бронзовый канделябр, Франция, 1877.

61-3:
Candlesticks.
Chandeliers.
Kerzenständer mit Umfassung.
Подсвечники.

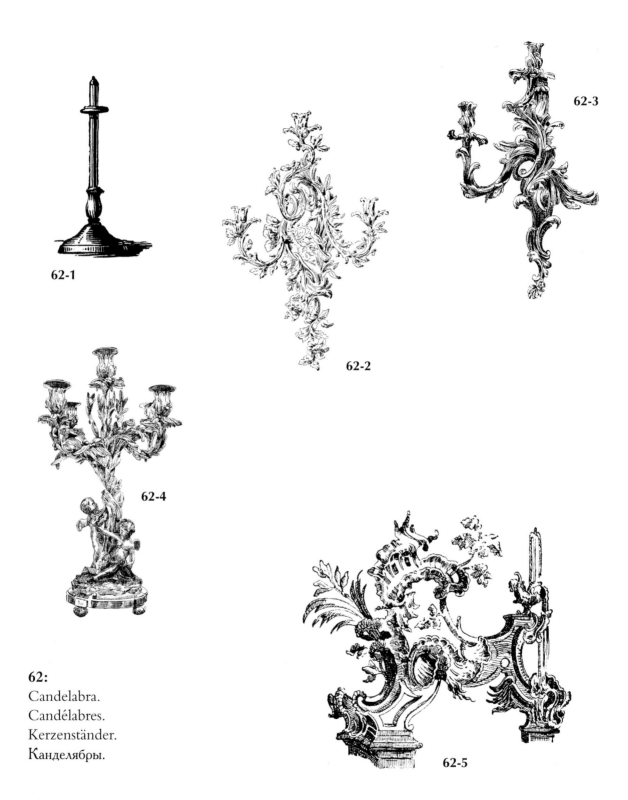

62-1

62-2

62-3

62-4

62-5

62:
Candelabra.
Candélabres.
Kerzenständer.
Канделябры.

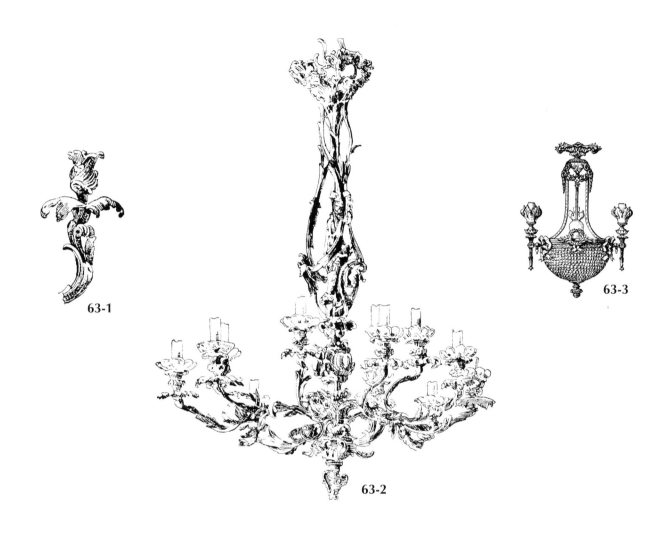

63-1

63-2

63-3

63:
Candlestick and chandeliers.
Candélabre et lustres.
Kerzenständer und Kronleuchter.
Подсвечник и канделябры.

64-1

64-2

64:
Candelabra.
Candélabres.
Kerzenständer.
Канделябры.

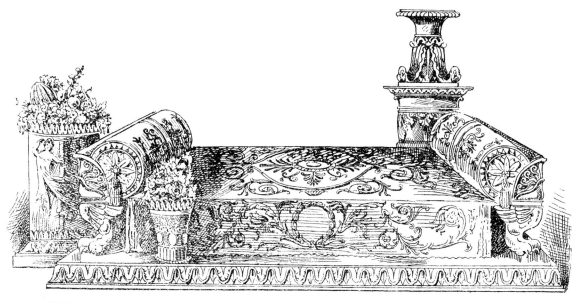

65-1

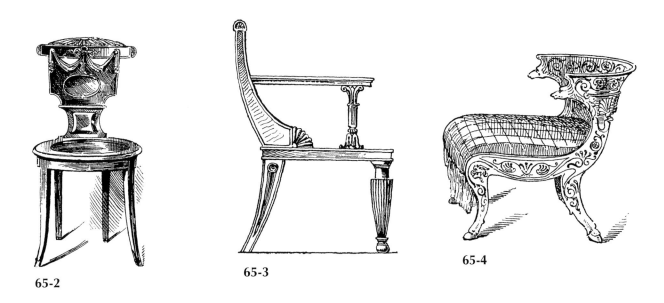

65-2

65-3

65-4

65-69:
Furniture, Empire style.
Mobilier, style Empire.
Mobiliar, Stil Empire.
Мебель, стиль эпохи правления Наполеона.

Thomas Arthur Strange. *English Furniture, Decoration, Woodwork and Allied Arts,* London, n.d.

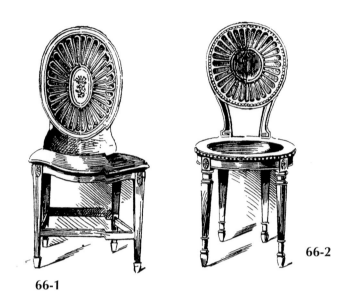

66-1

66-2

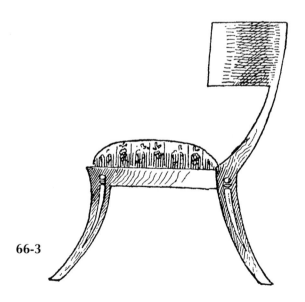

66-3

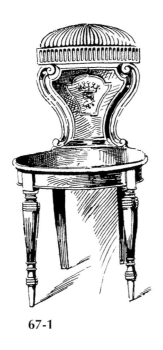

67-1

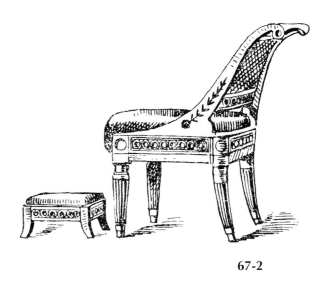

67-2

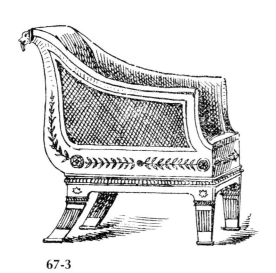

67-3

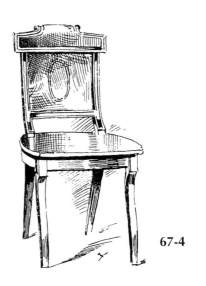

67-4

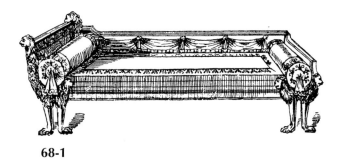

68-1

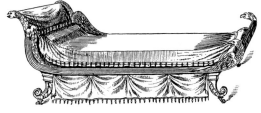

68-3

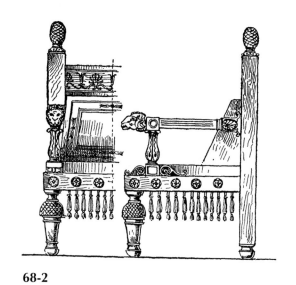

68-2

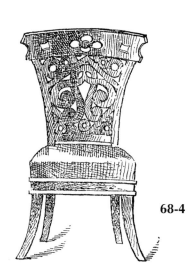

68-4

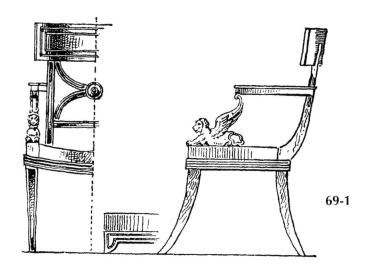

69-1

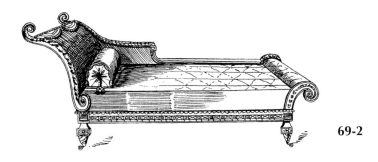

69-2

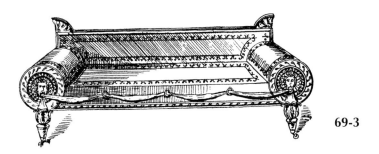

69-3

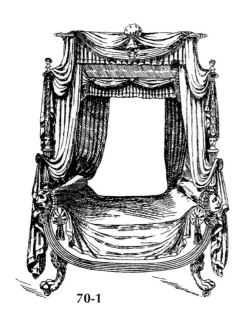

70-1

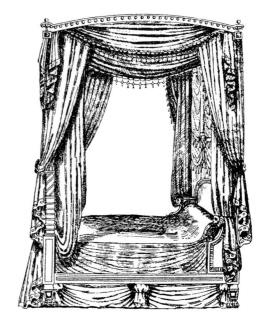

70-2

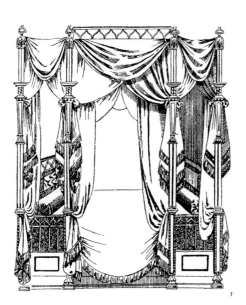

70-3

70-72:
Sheraton Bedsteads.
Lits à baldaquin Sheraton.
Sheraton Bedsteads.
Himmelbetten.
Остовы кровати в стиле шератон.

Thomas Arthur Strange. *English Furniture, Decoration, Woodwork and Allied Arts,* London, n.d.

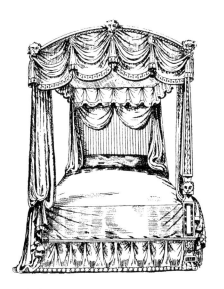

71-1

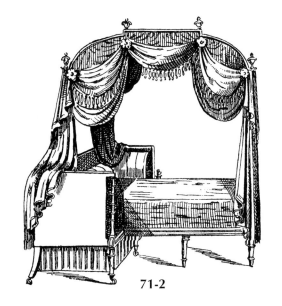

71-2

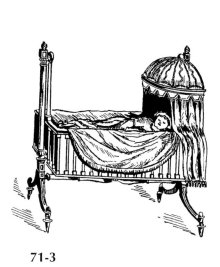

71-3

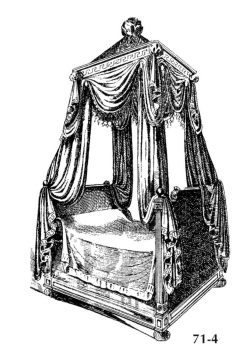

71-4

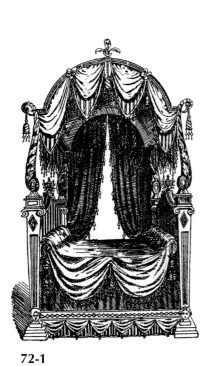

72-1

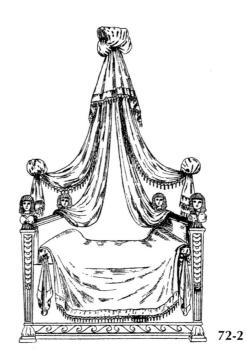

72-2

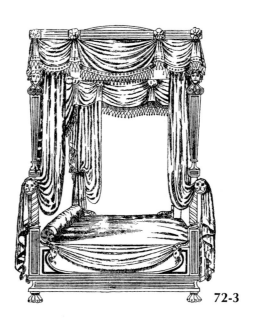

72-3

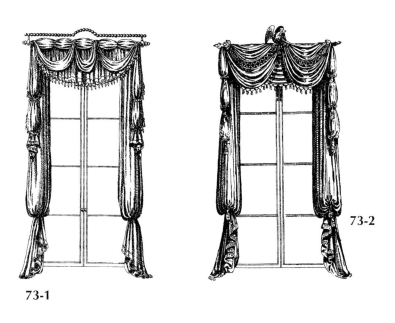

73-1

73-2

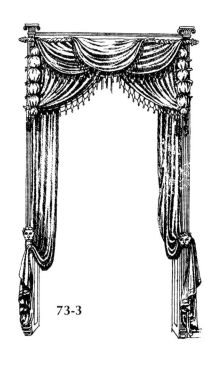

73-3

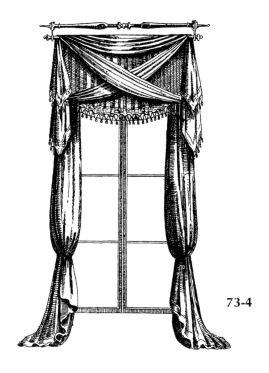

73-4

73–74:
Sheraton window draperies.
Rideaux Sheraton.
Sheraton Fenstervorhänge.
Оконные занавеси в стиле
шератон.

Thomas Arthur Strange.
English Furniture, Decoration,
Woodwork and Allied Arts,
London, n.d.

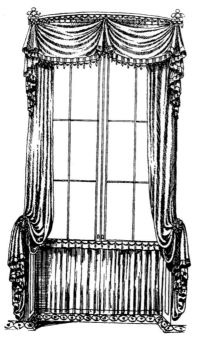

74-1

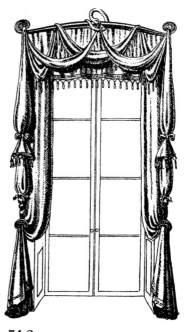

74-2

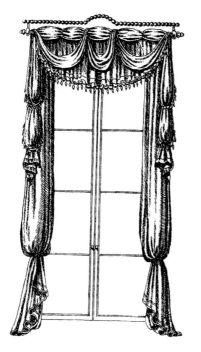

74-3

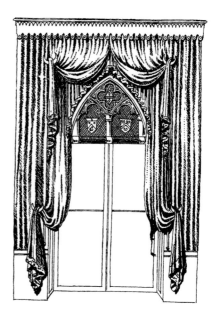

74-4

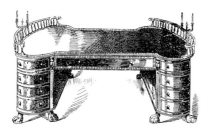

75-1

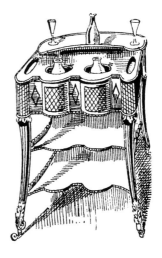

75-3

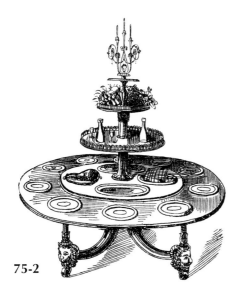

75-2

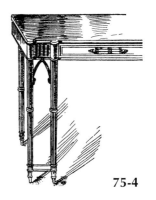

75-4

75–77:
Sheraton furniture.
Mobilier Sheraton.
Sheraton Möbel. Mobiliar Sheraton.
Мебель в стиле шератон.

Thomas Arthur Strange. *English Furniture, Decoration, Woodwork and Allied Arts,* London, n.d.

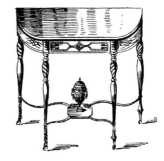

75-5

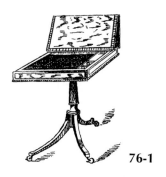

76-1

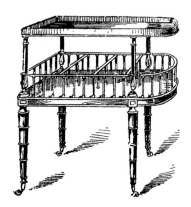

76-2

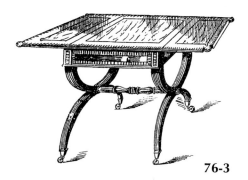

76-3

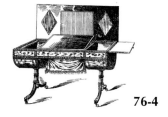

76-4

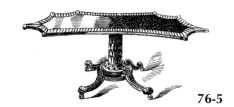

76-5

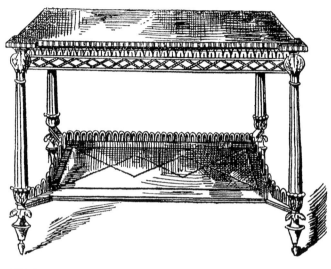

77-1

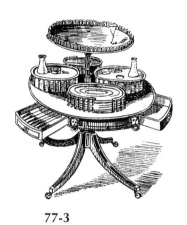

77-3

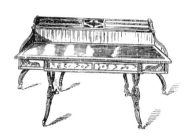

77-4

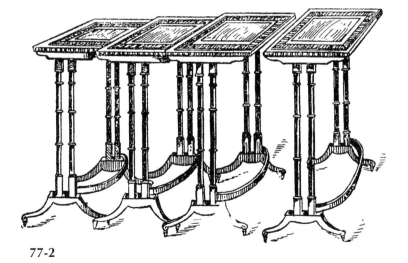

77-2

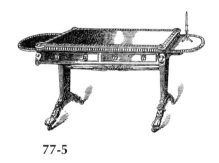

77-5

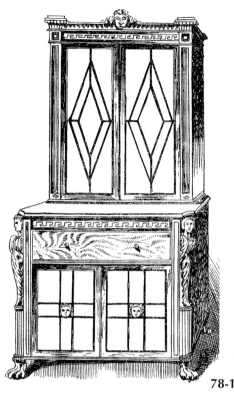

78-1

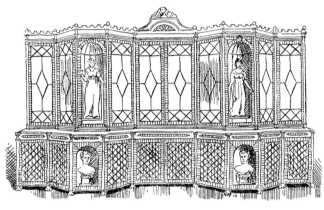

78-3

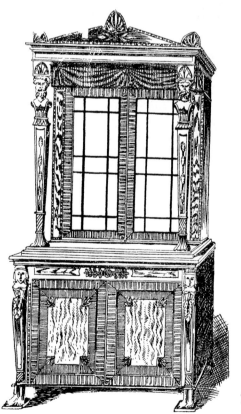

78-2

78, 79–1, 79–2:
Sheraton bookcases.
Bibliothèques Sheraton.
Sheraton Bücherschränke.
Книжные шкафы в стиле шератон.

79–3:
Writing desk.
Secrétaire Sheraton.
Schreibsekretär, Sheraton.
Письменный стол.

Thomas Arthur Strange. *English Furniture, Decoration, Woodwork and Allied Arts,* London, n.d.

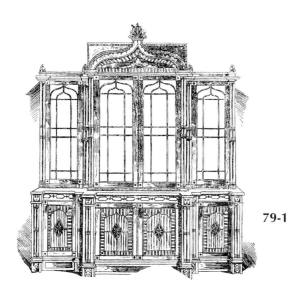

79-1

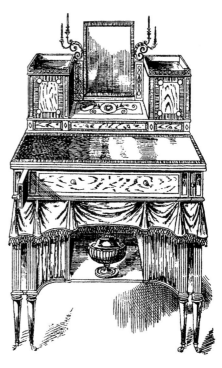

79-3

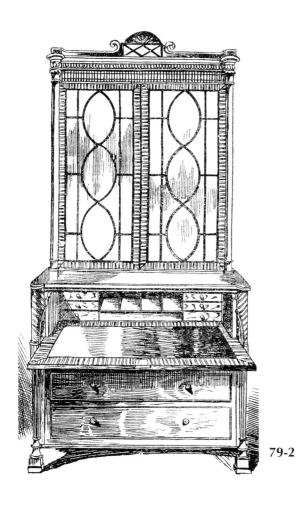

79-2

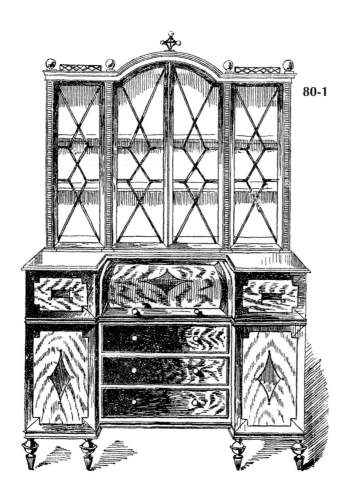

80-1

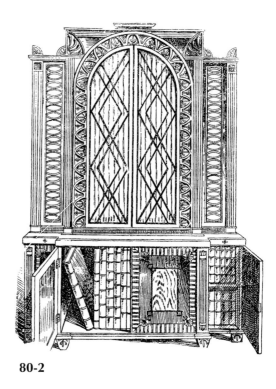

80-2

80, 81–1, 81–3:
Cabinets.
Schreibkabinette.
Шкафы.

81-2, 81-4:
Dressing commodes.
Commodes.
Ankleidekommoden.
Шкаф для одежды.

Thomas Arthur Strange. *English Furniture,
Decoration, Woodwork and Allied Arts,* London,
n.d.

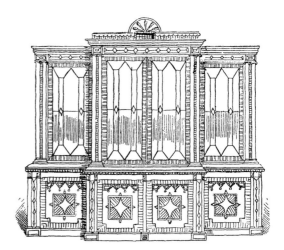

80-3

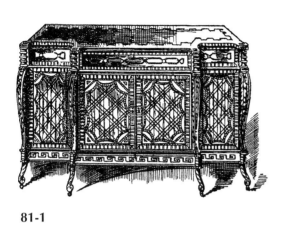

81-1

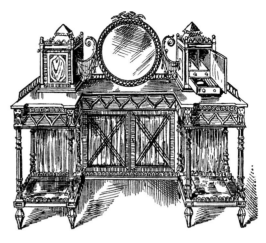

81-2

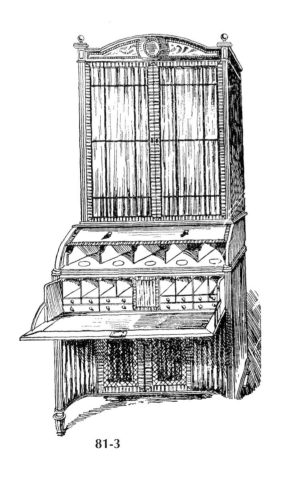

81-3

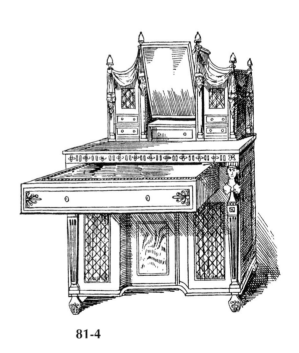

81-4

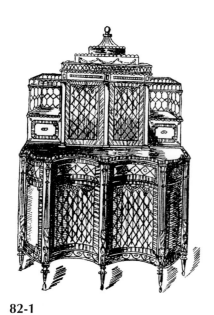

82-1

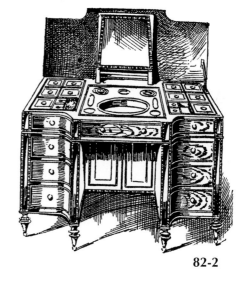

82-2

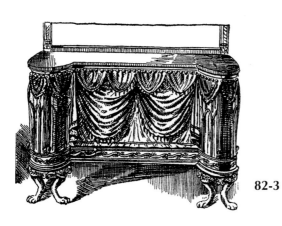

82-3

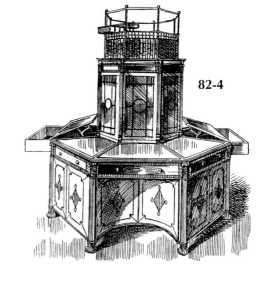

82-4

82-1:
Cabinet.
Schreibkabinett.
Шкаф.

82-2:
Washstand.
Coiffeuse.
Frisierkommode.
Умывальник.

82-3:
Sideboard.
Desserte.
Anrichte.
Сервант.

82-4:
Bookcase.
Bibliothèque.
Bücherschrank.
Книжный шкаф.

Thomas Arthur Strange. *English Furniture, Decoration, Woodwork and Allied Arts,* London, n.d.

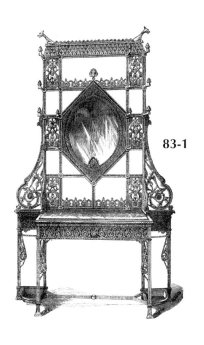

83-1

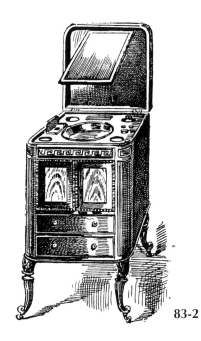

83-2

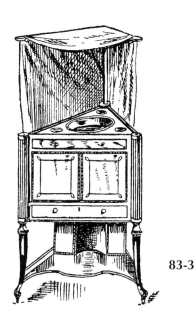

83-3

83-1:
Dressing commode.
Commode.
Ankleidekommoden.
Шкаф для одежды.

83-2, 83-3:
Washstand.
Coiffeuse.
Frisierkommode.
Умывальники.

83-4:
Cabinet.
Шкаф.

Thomas Arthur Strange. *English Furniture,
Decoration, Woodwork and Allied Arts,* London, n.d.

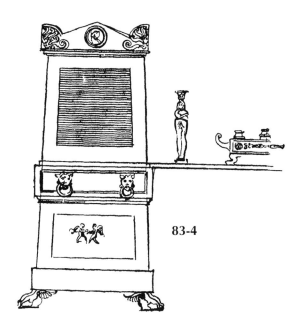

83-4

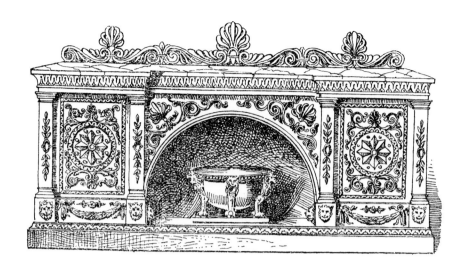

84-1

84-2

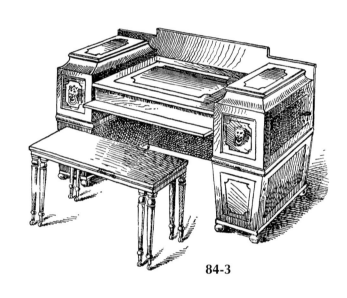

84-3

84-4

84-1, 84-2:
Stoves.
Poêles.
Öfen.
Печи.

84-3:
Writing desk.
Secrétaire.
Schreibsekretär.
Письменный стол.

84-4:
Footrest.
Repose-pieds.
Fußstütze.
Подставка для ног.

Thomas Arthur Strange. *English Furniture, Decoration, Woodwork and Allied Arts*, London, n.d.

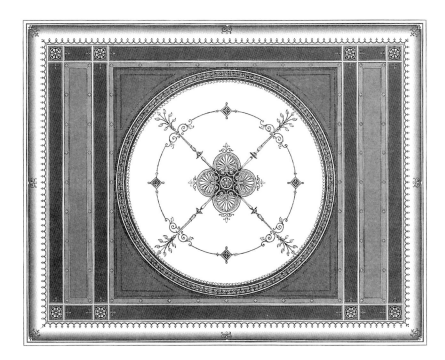

Painted ceiling,
1870.
Plafond peint, 1870.
Deckenmalerei,
1870.
Расписанный
потолок, 1870

85

• Architecture •
• Architektur •
• Архитектура •

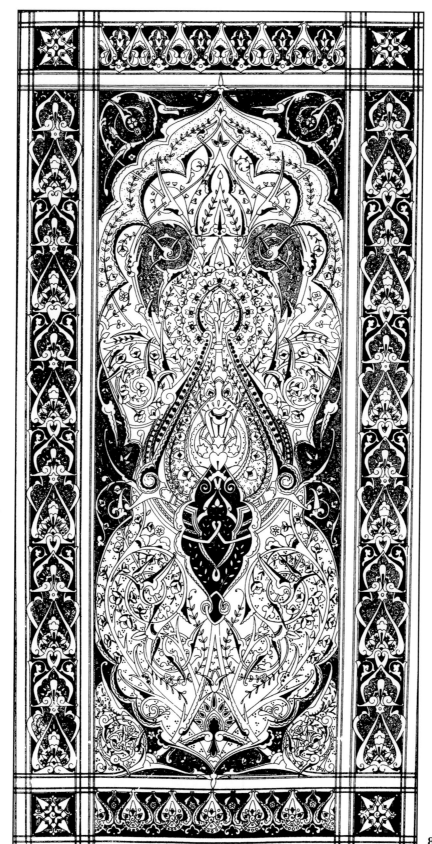

Wall panel.
Panneau mural.
Wandbehang.
Стенная панель.

Christopher
Dresser, *Modern
Ornamentation*,
1886.

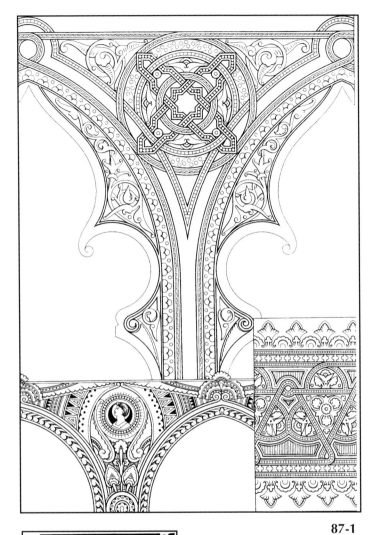

87-1:
Wall decoration.
Décors muraux.
Wanddekorationen.
Отделка стен.

Christopher Dresser,
Studies in Design, 1874-
1876.

87-1

87-2:
Ceiling.
Plafond.
Deckenteil.
Потолок.

C. P. Millier et H. Childs, *Decoration,* 1886.

87-2

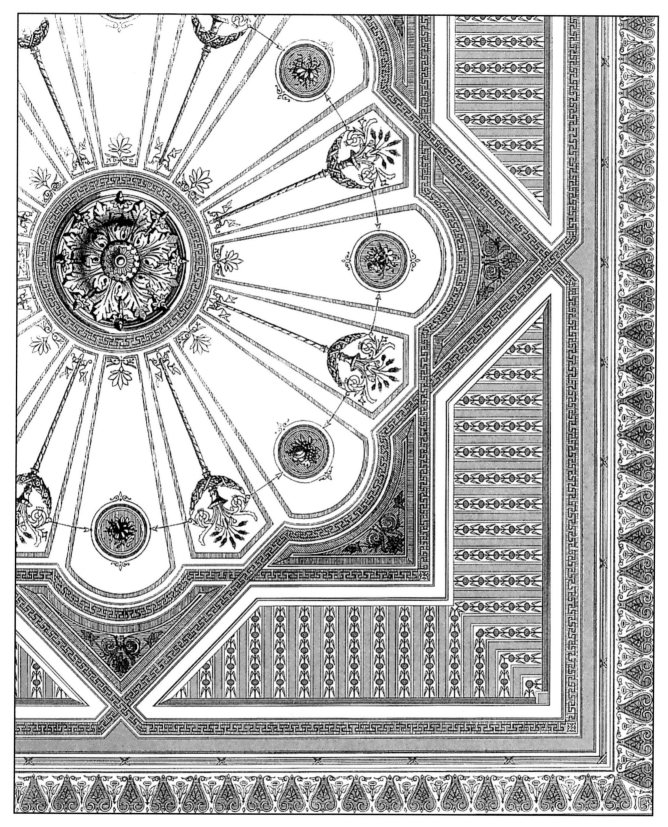

88

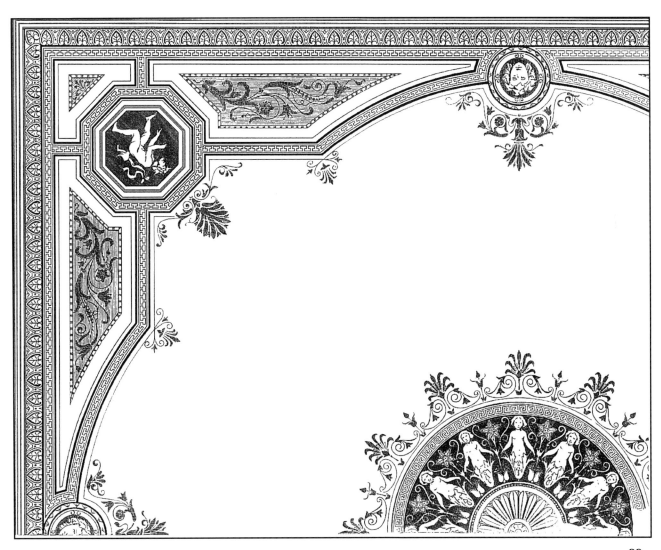

88–89:
Painted ceilings, 1870.
Plafonds peints, 1870.
Deckenmalerei, 1870.
Расписанные потолки, 1870.

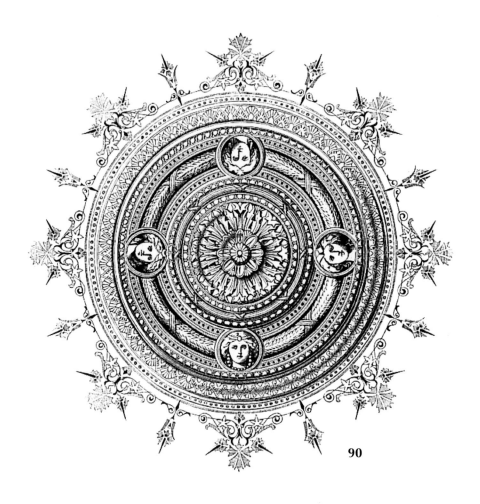

90

90-91:
Stucco ceiling roses, 1870.
Rosaces en stuc, 1870.
Stuckrosetten, 1870.
Потолок, украшенный розами, лепнина, 1870.

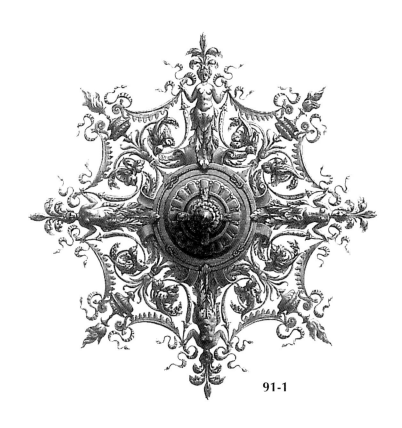

91-1

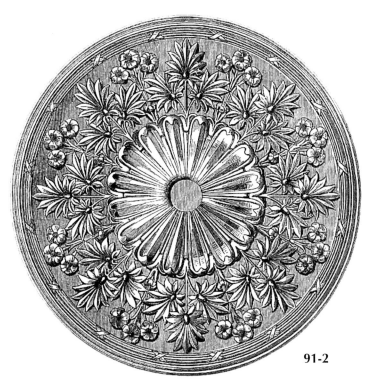

91-2

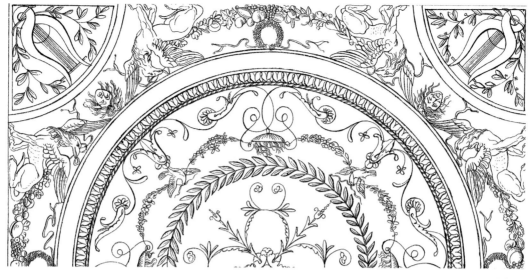

92-1

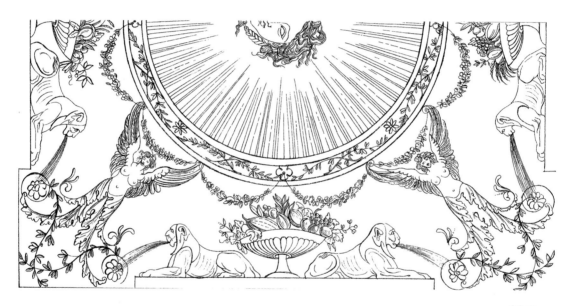

92-2

92-97:
Rudolph Ackerman, *Selection of Ornaments in Forty Pages for the Use of Sculptors, Painters, Carvers, Modellers, Chasers, Embossers, etc.,* 1817-1819.

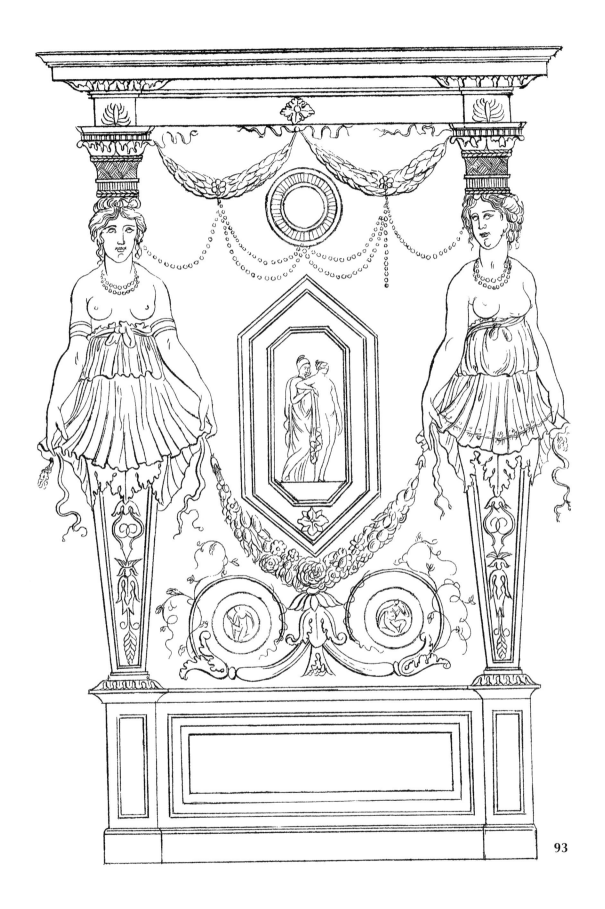

93

94-1

94-2

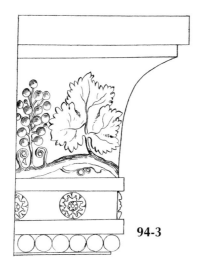

94-3

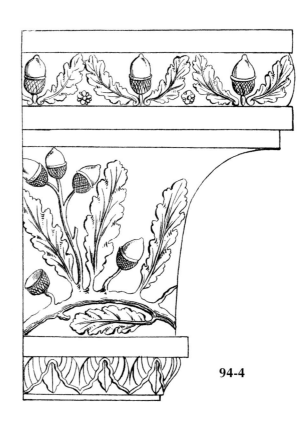

94-4

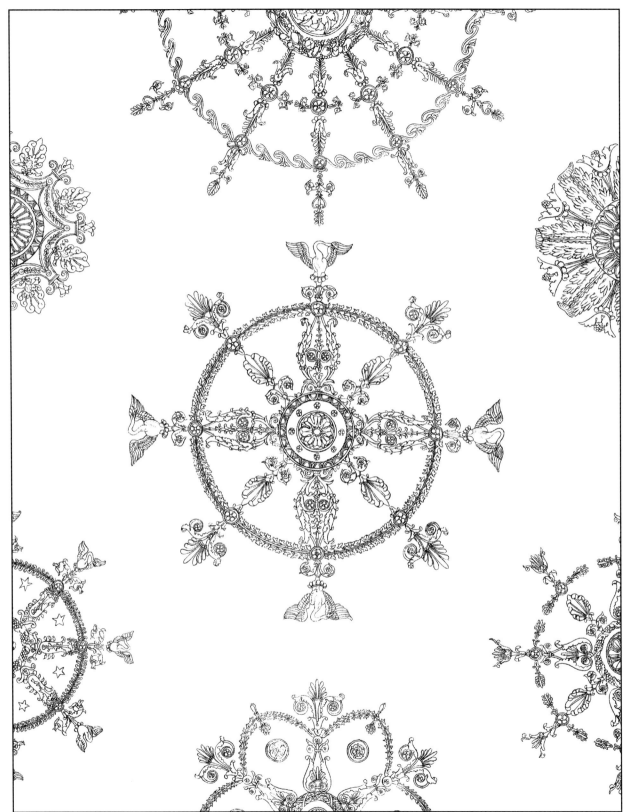

95

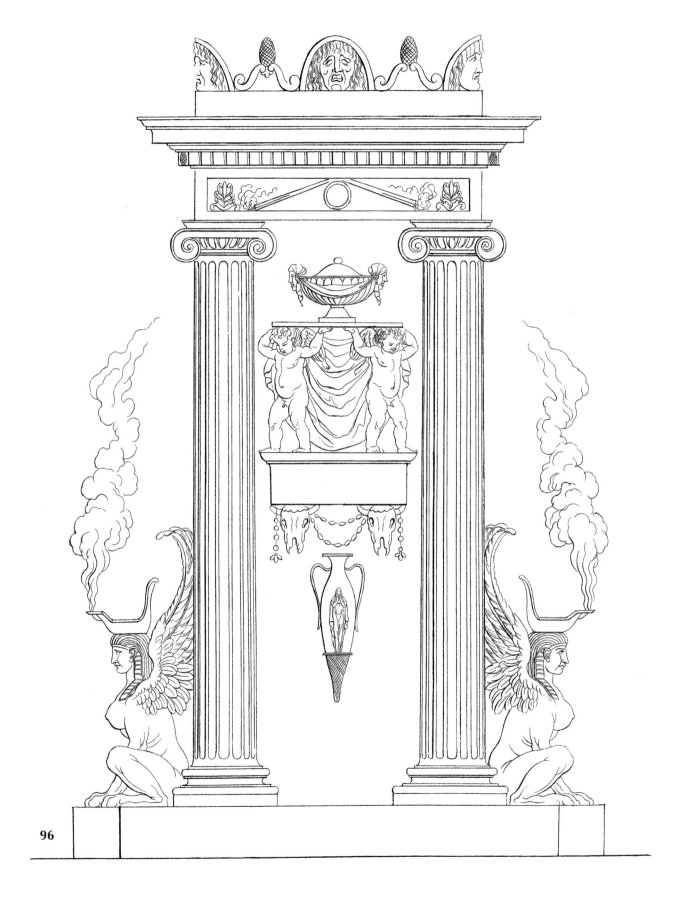

96

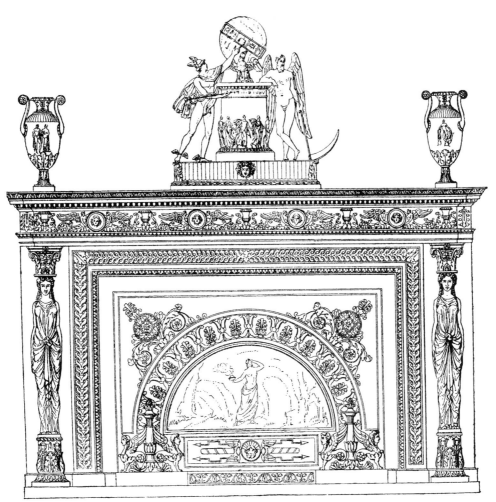

97-1

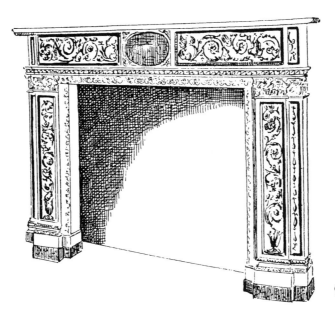

97-2

Stained glass.
Vitrail.
Glasmalerei.
Цветное стекло.

Christopher Dresser, *Studies in Design*, 1874-1876.

98

99-1

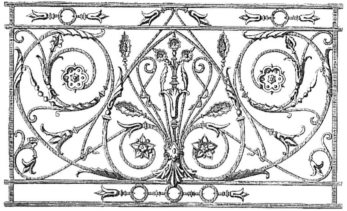

99-2

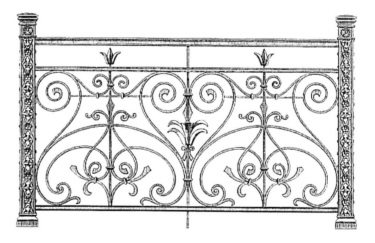

99-3

99–100:
Ironwork balustrades.
Balustrades en fer forgé.
Brüstungen
aus geschmiedetem Eisen
Металлические
балюстрады.

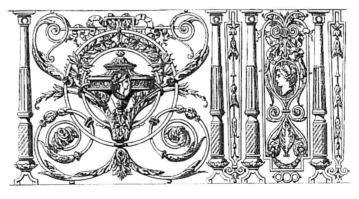

99-4

99

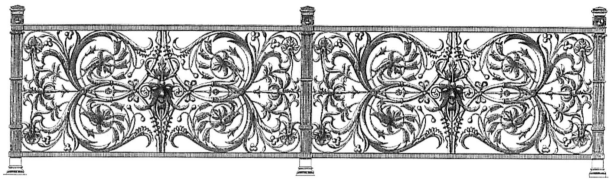

100-1

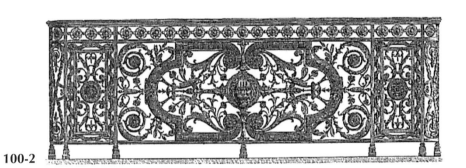

100-2

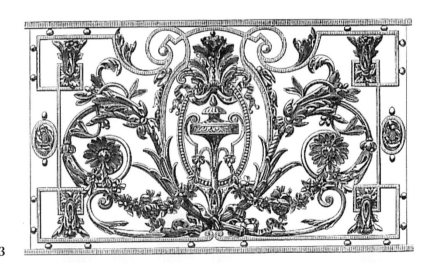

100-3

100

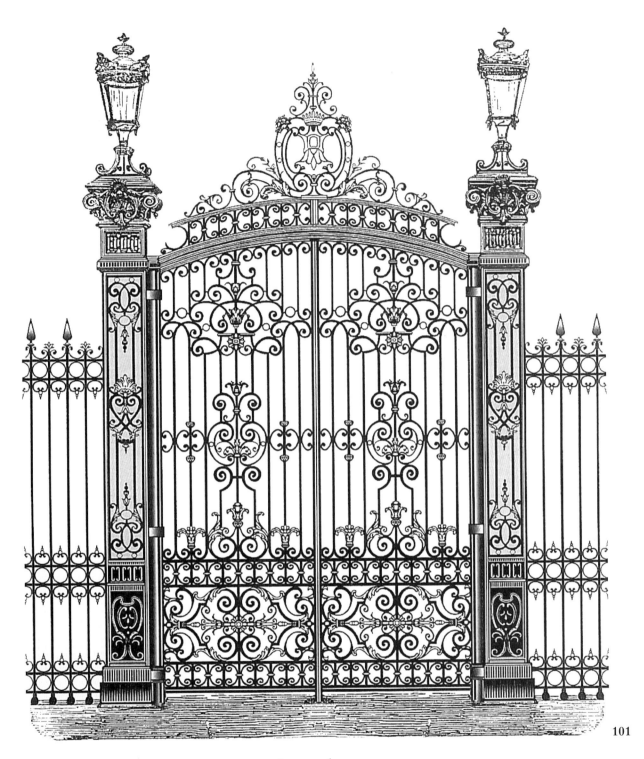

Ironwork gate.
Grille en fer forgé.
Eingangstor aus geschmiedetem Eisen.
Железные ворота.

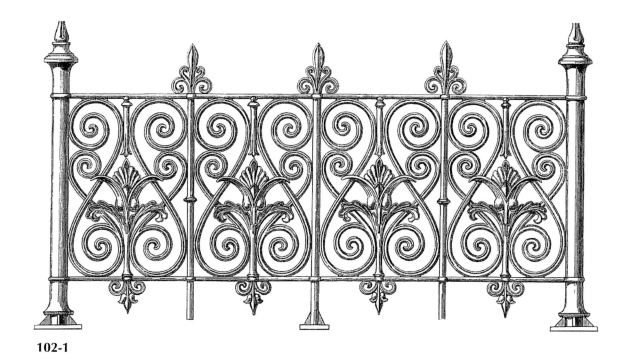

102-1

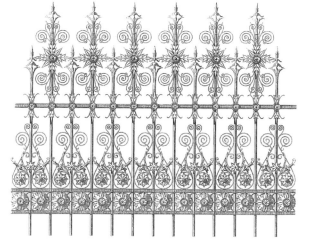

102-3

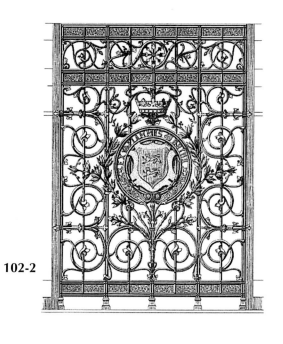

102-2

102-1:
Ironwork balustrade.
Balustrade en fer forgé.
Brüstung aus geschmiedetem Eisen.
Металлическая балюстрада.

102-2, 102-3:
Ironwork gates.
Grilles en fer forgé.
Gitter aus geschmiedetem Eisen.
Железные ворота.

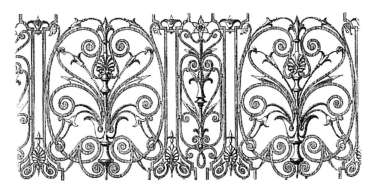

103-1

103-2

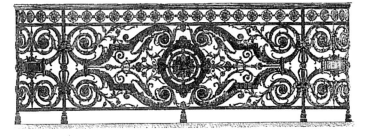

103-3

103:
Ironwork balustrades.
Balustrades en fer forgé.
Brüstung aus
geschmiedetem Eisen.
Металлические балюстрады.

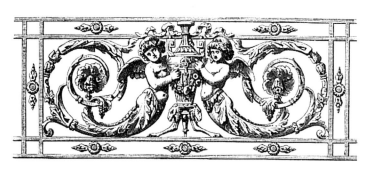

103-4

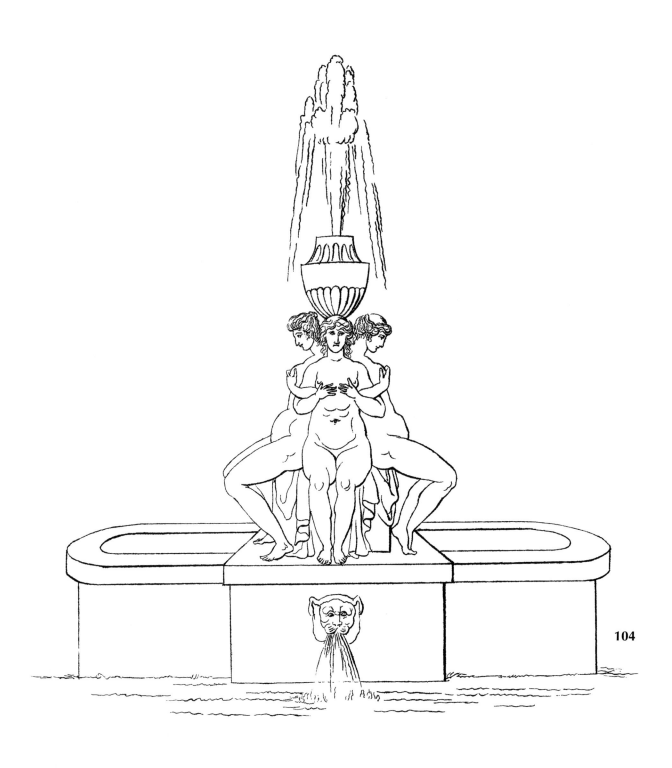

Rudolph Ackerman, *Selection of Ornaments in Forty Pages for the Use of Sculptors, Painters, Carvers, Modellers, Chasers, Embossers, etc.*, 1817–1819.

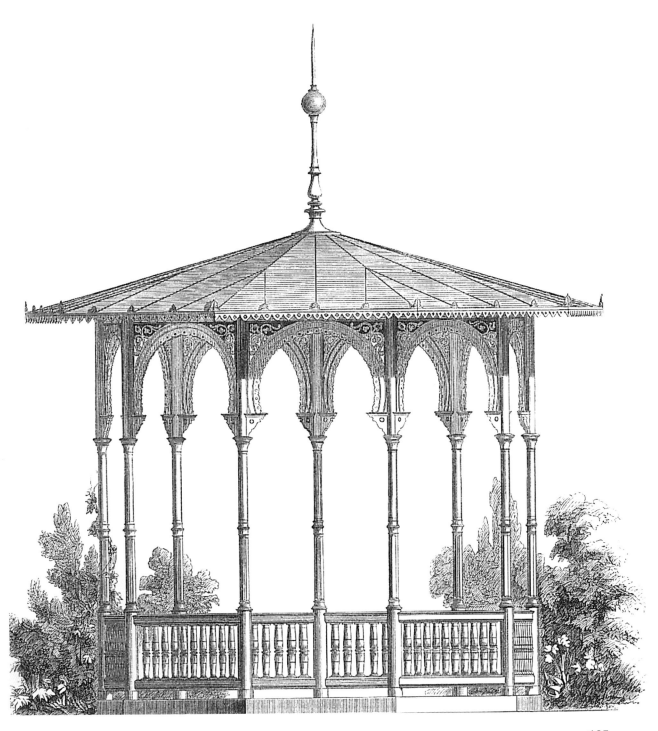

105

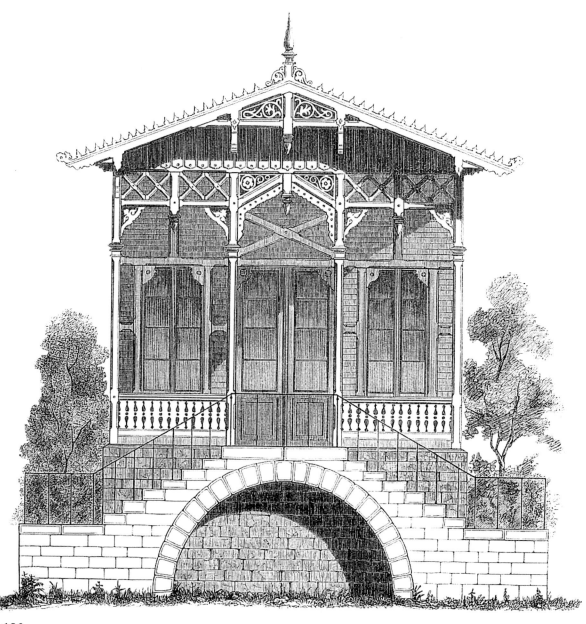

106

105, 106:
Pavilion, 1870.
Kiosque, 1870.
Павильон, 1870.

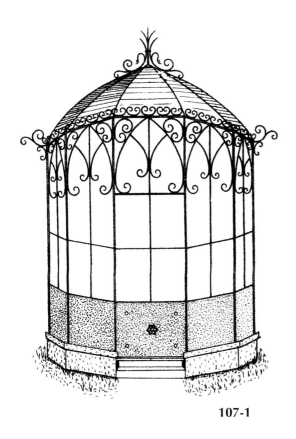

107-1

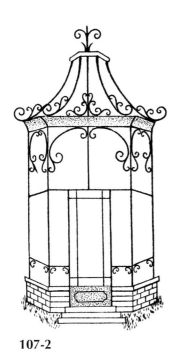

107-2

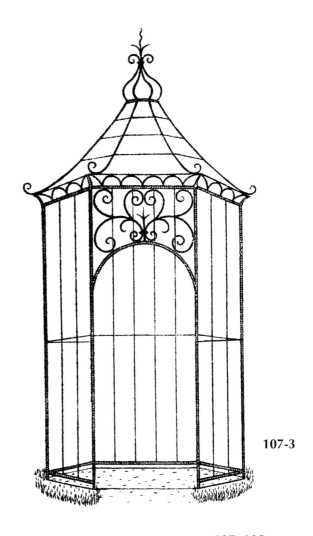

107-3

107–108
Pavilions, Italy, 1870.
Kiosques, Italie, 1870.
Kiosks, Italien, 1870.
Павильоны, Италия, 1870.

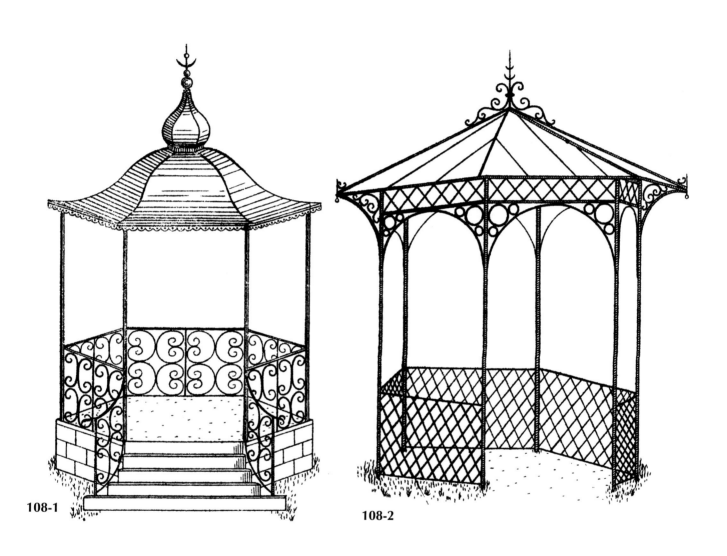

108-1

108-2

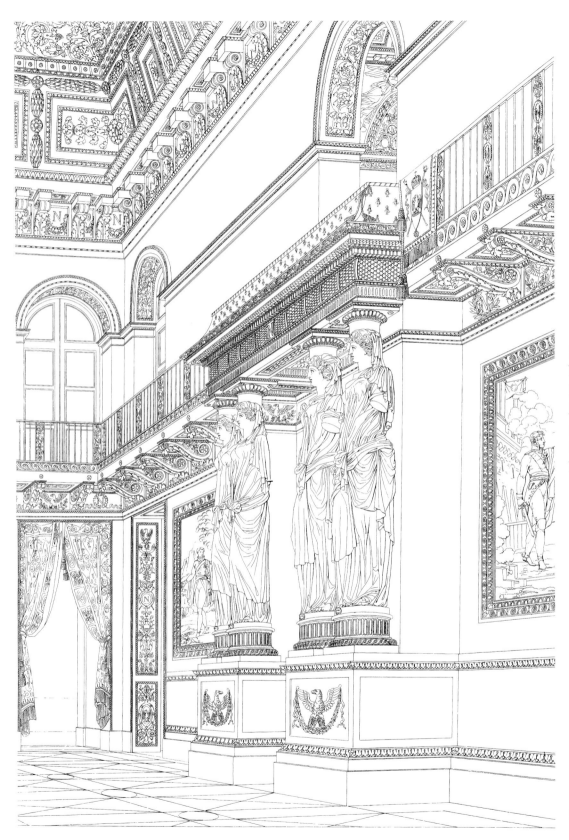

109–121:
Percier et
Fontaine,
*Recueil de
décorations
intérieures,*
Paris, 1801.

109

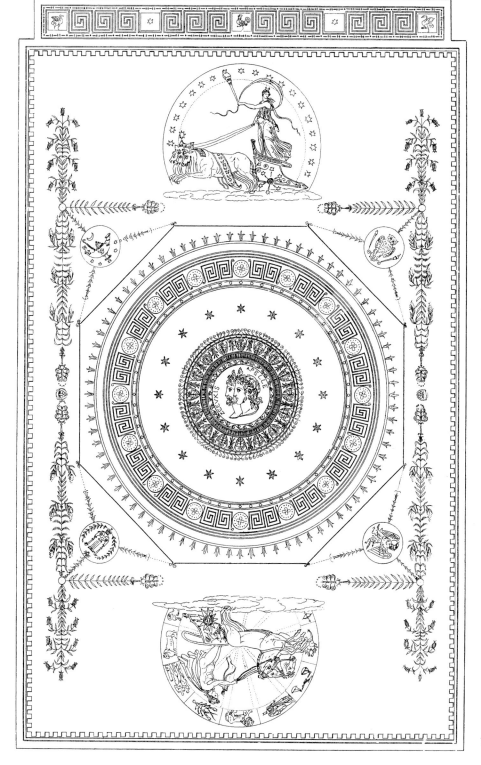

110

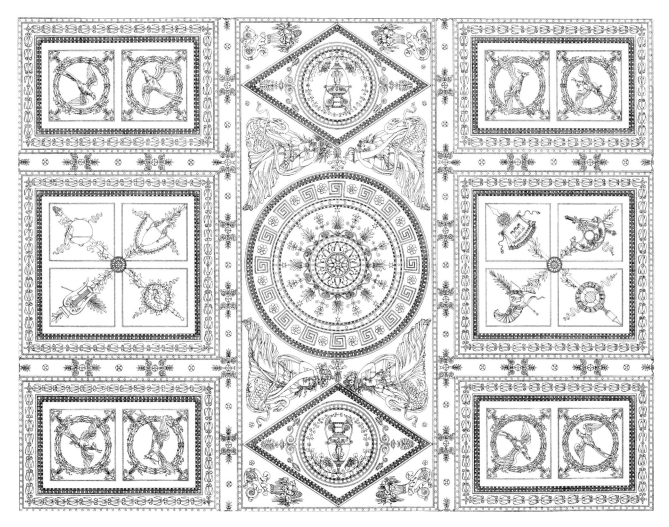

111

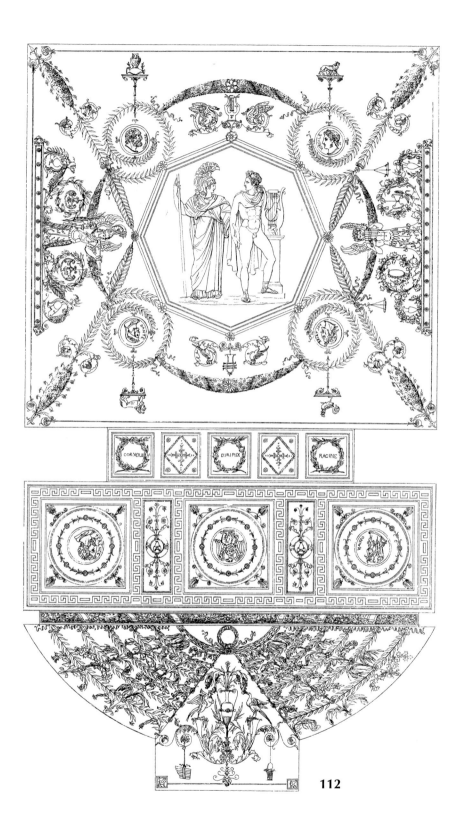

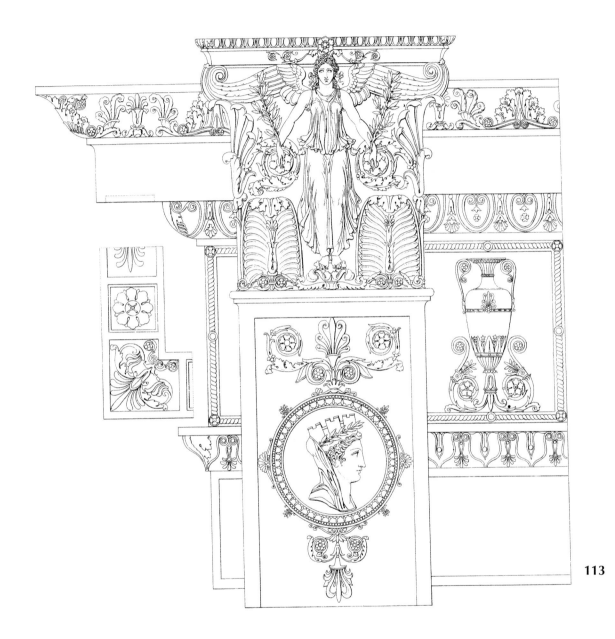

113

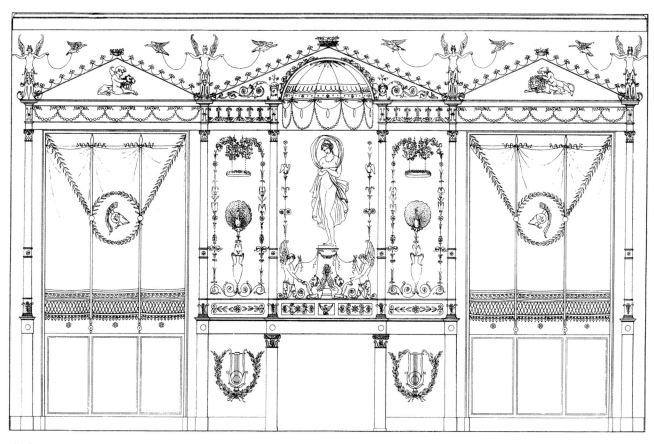

114

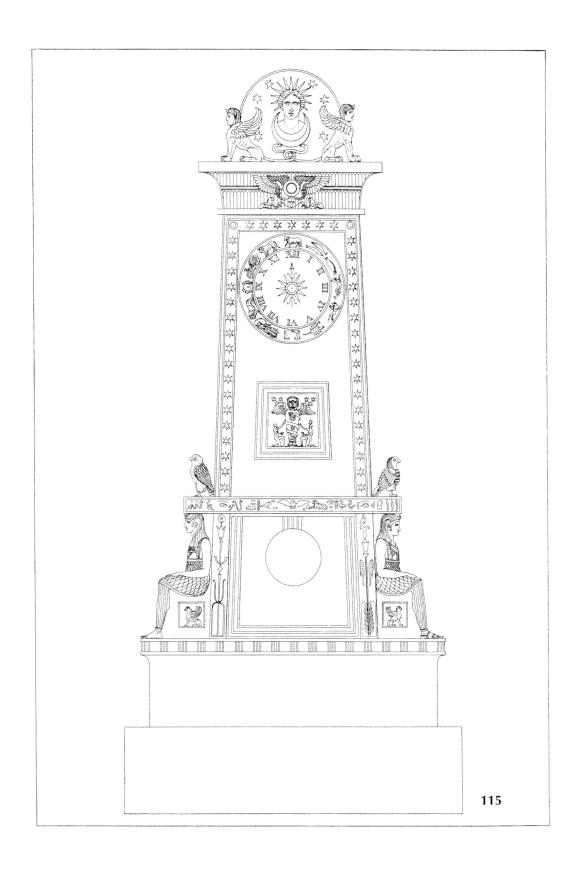

115

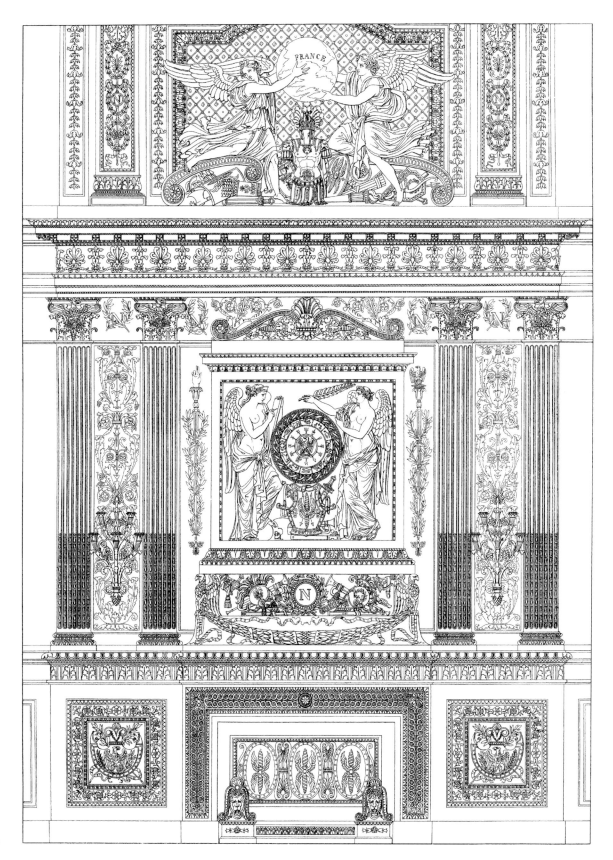

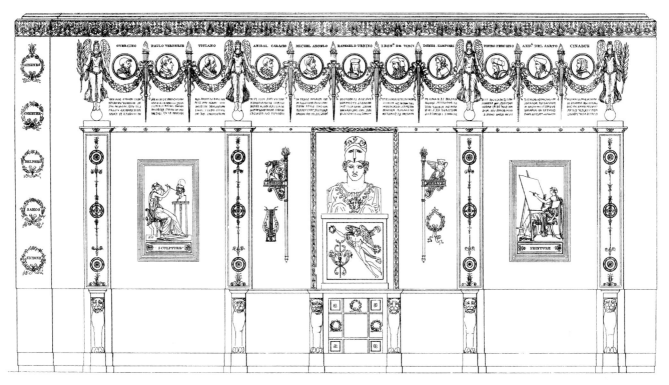

117

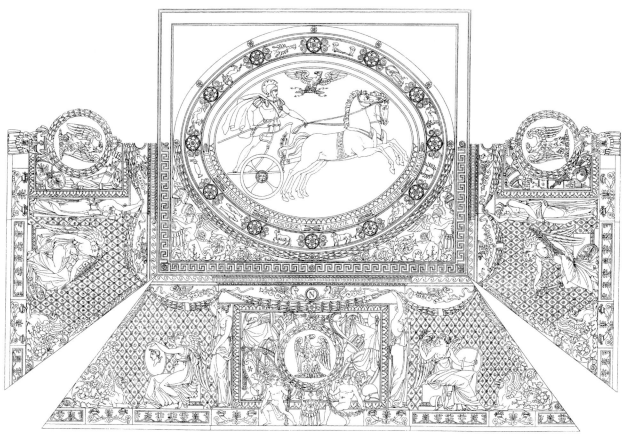

118

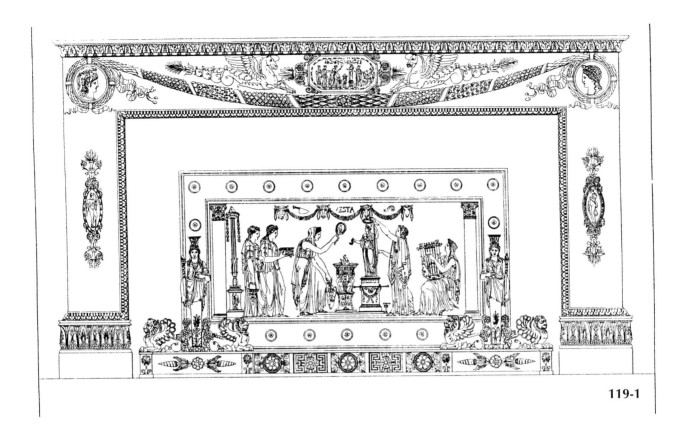

119-1

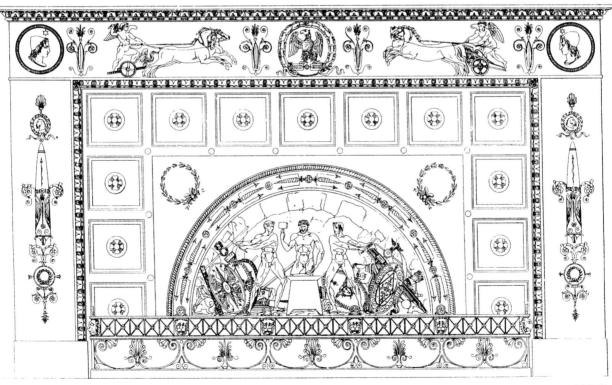

119-2

119

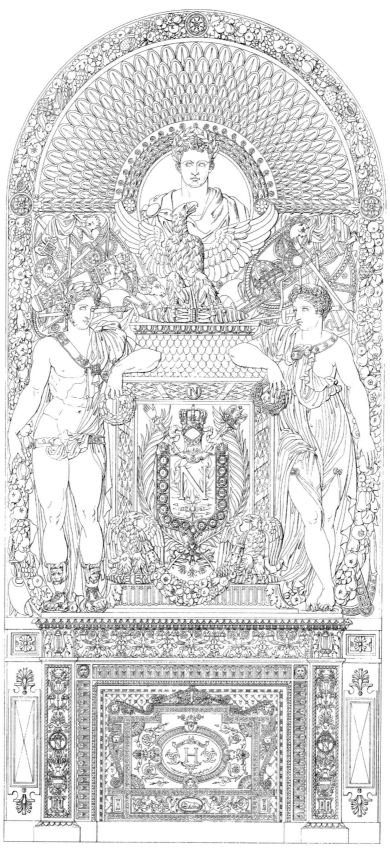

120

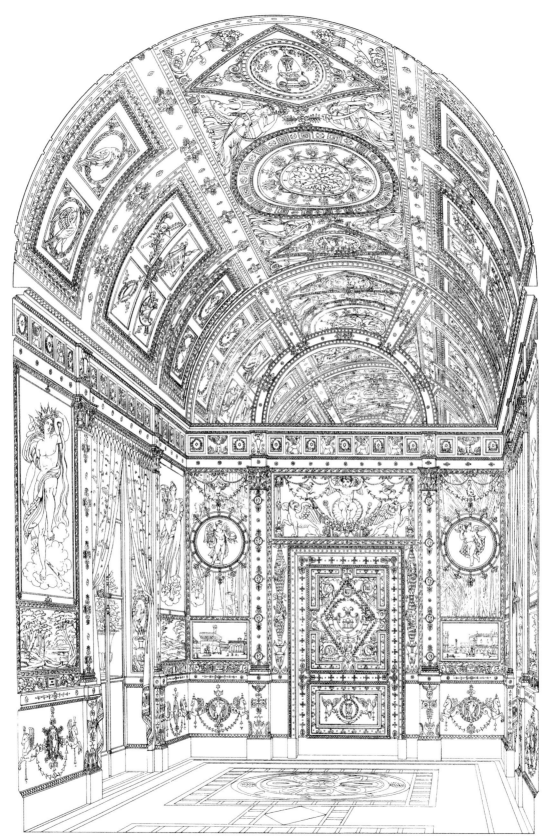

121

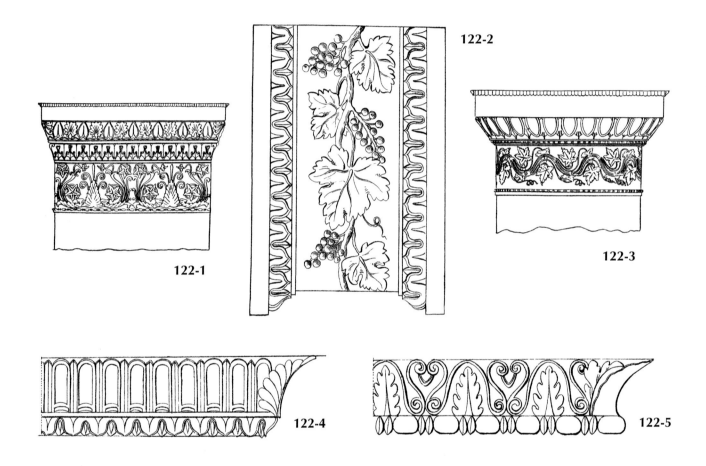

122-1

122-2

122-3

122-4

122-5

122–124:
Rudolph Ackerman, *Selection of Ornaments in Forty Pages for the Use of Sculptors, Painters, Carvers, Modellers, Chasers, Embossers, etc.*, 1817–1819.

123-1

123-2

123-3

123-4

123-5

124-1

124-2

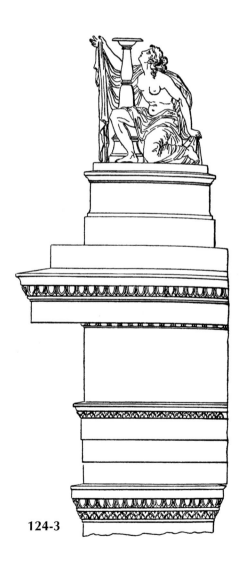

124-3

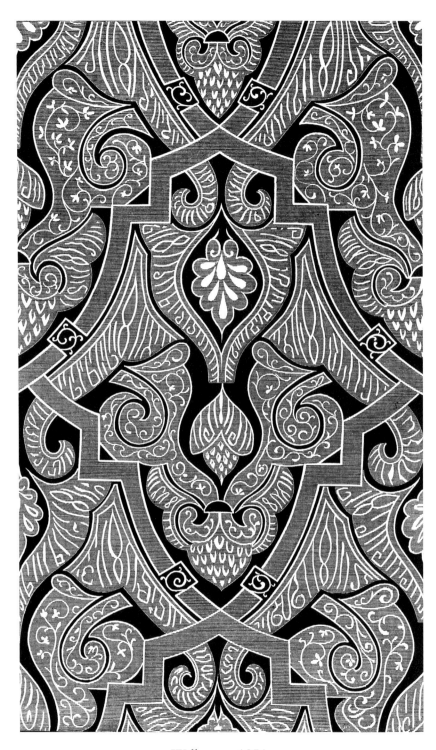

Wallpaper, 1851.
Papier peint, 1851.
Papier bemalt, 1851.
Обои, 1851.

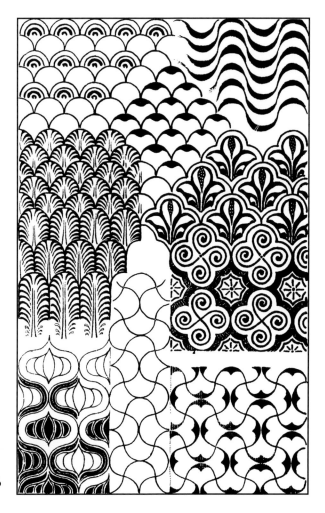

Scale patterns.
Ogives.
Musterreihen.
Повторяющиеся орнаменты.

Lewis F. Day, *The Planning of Ornament*, 1887.

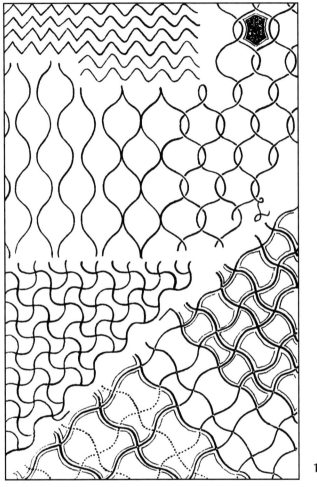

127

Waves.
Vagues.
Schlangen.
Волны.

Lewis F. Day, *Anatomy of Pattern*, 1898.

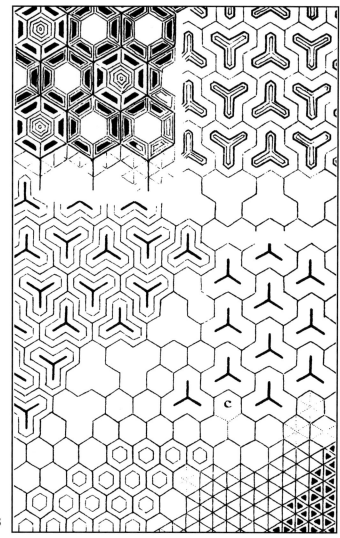

128

Honeycomb and diapers.
Alvéoles.
Bienenwabenmuster.
Сотовые орнаменты.

Lewis F. Day, *Anatomy of Pattern,* 1898.

129

129–131:
Typographic vignette.
Vignettes typographiques.
gedruckte Vignetten.
Типографическая
виньетка.

Christopher Dresser, *The Art of Decorative Design*, 1862.

• Typography •
• Typographie •
• Типография •

130-2

130-3

130-1

130-5

130-6

130-4

130-7

130-9

130-8

130-10

130

 131-1

 131-2

 131-3

 131-4

 131-5

 131-6

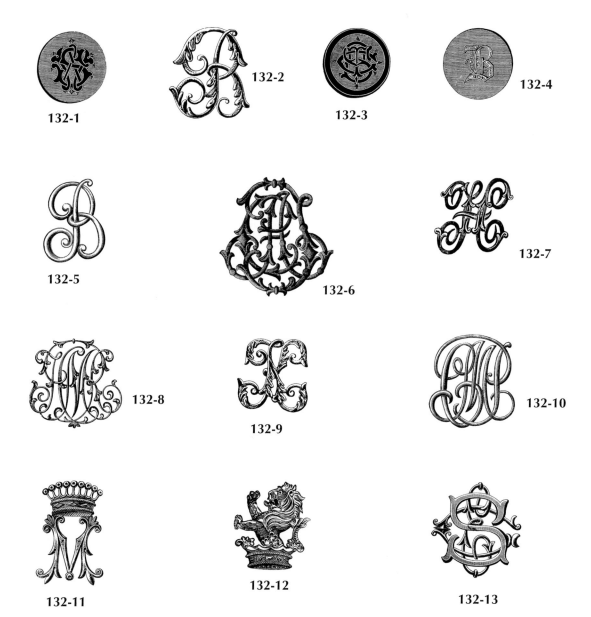

132-1

132-2

132-3

132-4

132-5

132-6

132-7

132-8

132-9

132-10

132-11

132-12

132-13

132–133:
Monograms.
Monogrammes.
Monogramme.
Монограммы.

Moseman's Illustrated Guide for Purchasers of
Horse Furnishing Goods, New York, n.d.

133-1

133-2

133-3

133-4

133-5

133-6

133-7

133-8

133-9

133-11

133-10

133-12

134-1

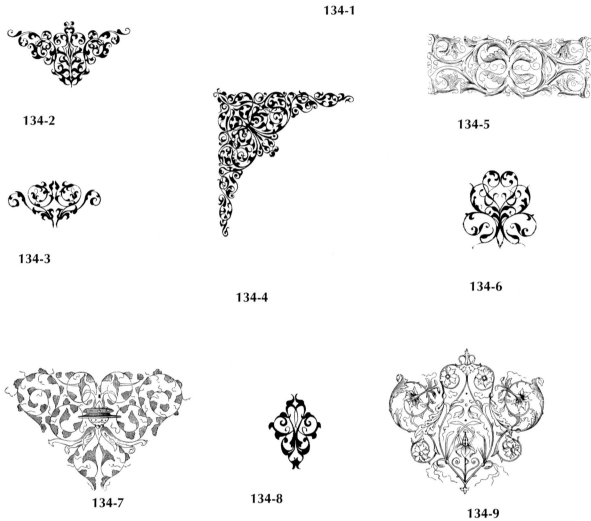

134-2

134-3

134-4

134-5

134-6

134-7

134-8

134-9

134-136:
Typographic vignettes.
Vignettes typographiques.
Typographische Vignetten.
Типографические виньетки.

135-1

135-2

135-3

135-4

136-1

136-2

136-3

136-4

136-5

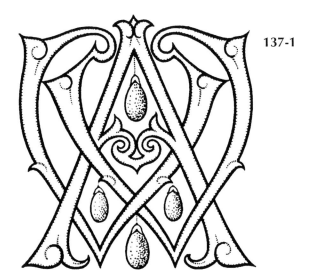

137-1

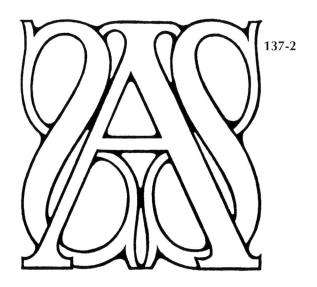

137-2

137:
Monograms.
Monogrammes.
Monogramme.
Монограммы.

138-1

138-2

138-3

138-4

138–145:
Typographic vignettes.
Vignettes typographiques.
Gedruckte Vignetten.
Типографические виньетки.

139-1

139-2

139-3

139-4

139-5

140-2

140-3

140-1

140-5

140-4

140-7

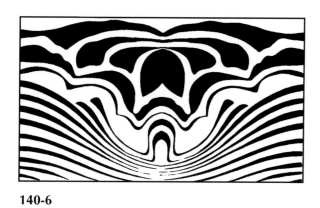

140-6

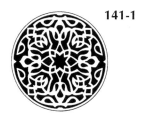

141-1

141-3

141-2

141-4

142-1

142-2

142-3

142-4

142-5

143-1

143-2

143-3

143-4

143-5

 144-1

 144-2

 144-3

 144-4

 144-5

 144-6

 144-7

 144-8

 144-10

 144-9

 145-1

 145-2

 145-3

 145-4

 145-5

 145-6

 145-7

 145-8

 145-9

 145-10

146-1

146-2

146-165:
Monograms.
Monogrammes.
Monogramme.
Монограммы.

146-3

147-1

147-2

147-3

147-4

147-5

148-1

148-2

148-3

148-4

149-1

149-2

149-3

149-4

149-5

150-1

150-4

150-2

150-3

150-5

151-1

151-2

151-3

152-1

152-2

152-3

152-4

152-5

153-1

153-2

153-3

153-4

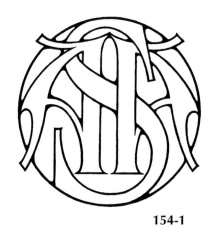

154-1

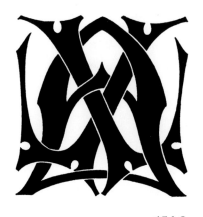

154-2

154-3

154-4

155-1

155-2

155-3

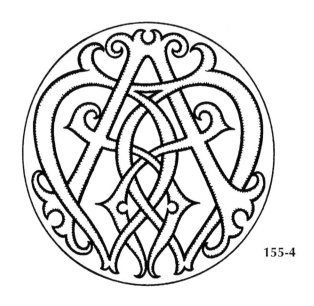

155-4

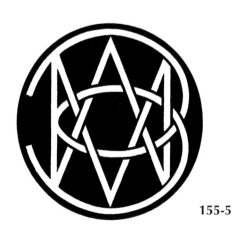

155-5

156-1

156-2

156-3

156-4

157-1

157-2

157-3

158-1

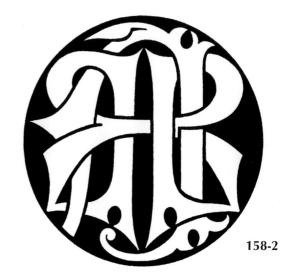

158-2

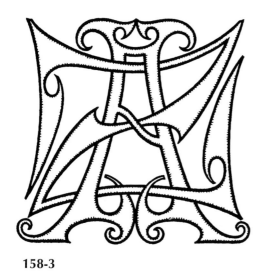

158-3

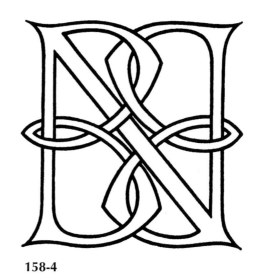

158-4

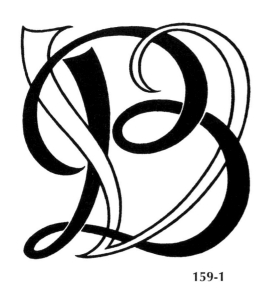

159-1

159-2

159-3

159-4

160-1

160-2

160-3

161-1

161-2

161-3

161-4

162-1

162-2

162-3

163-1

163-2

163-3

164-1

164-2

164-3

164-4

164-5

165-1

165-2

165-3

165-4

166-1

166-2

166-3

166-4

166-5

166-6

166-7

166:
Typographic vignettes.
Vignettes typographiques.
Gedruckte Vignetten.
Типографические виньетки.

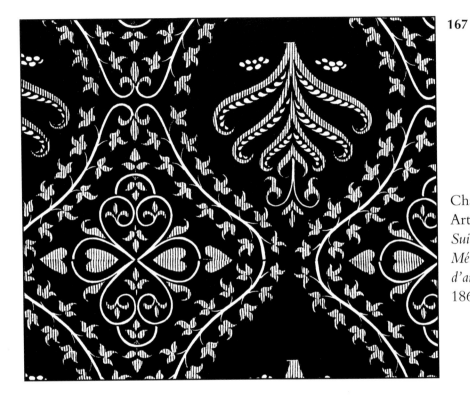

Charles Cahier,
Arthur Martin,
*Suite aux
Mélanges
d'archéologie,*
1868.

• Textiles •
• Textilien•
• Ткани •

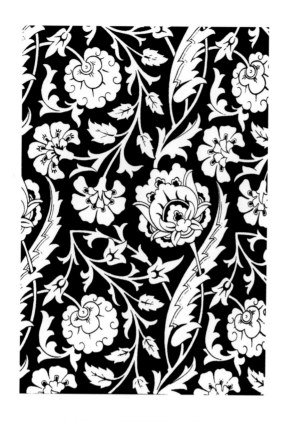

168-1

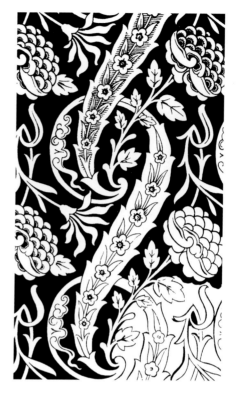

168-3

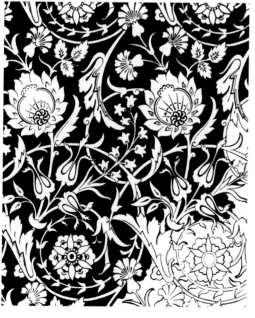

168-2

168–171:
Damask curtains.
Rideaux damasquinés.
Tauschierte Vorhänge.
Шторы из дамасской ткани.

Christopher Dresser, *Modern Ornamentation*, 1886.

169-1

169-2

169-3

170-1

170-2

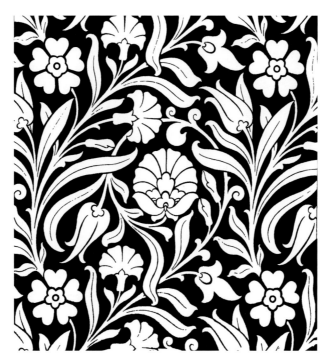

170-3

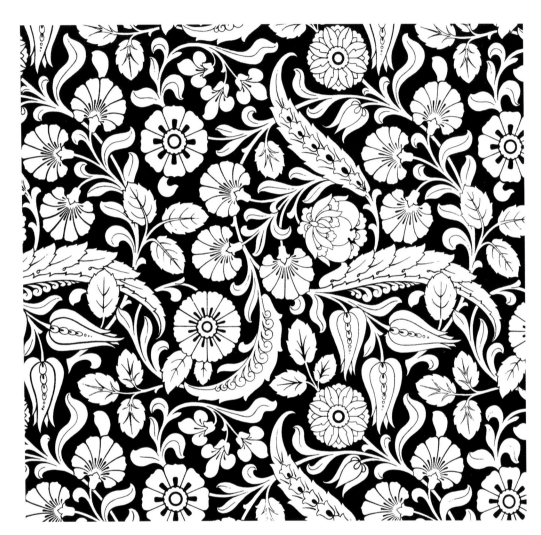

171

172

Tapestry.
Tapisserie.
Гобелен.

Walter J. Pierce, *Decoration,* septembre
1882.

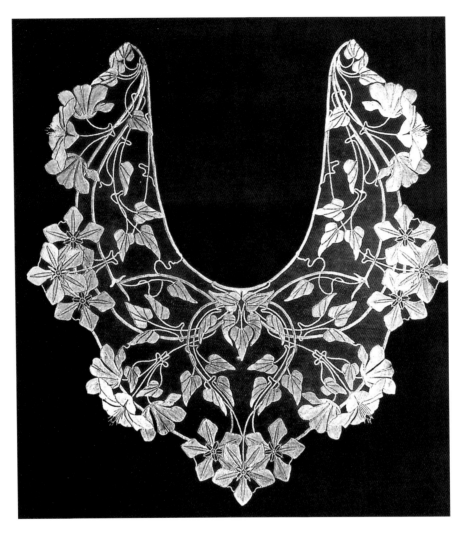

173

Collar, lacework, Austria.
Col de dentelle, Autriche.
Spitzenkragen, Österreich.
Воротник, кружево, Австрия.

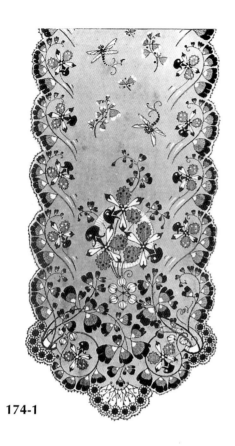

174-1

174-178:
Lacework, France.
Dentelle, France.
Spitzen, Frankreich.
Кружева, Франция.

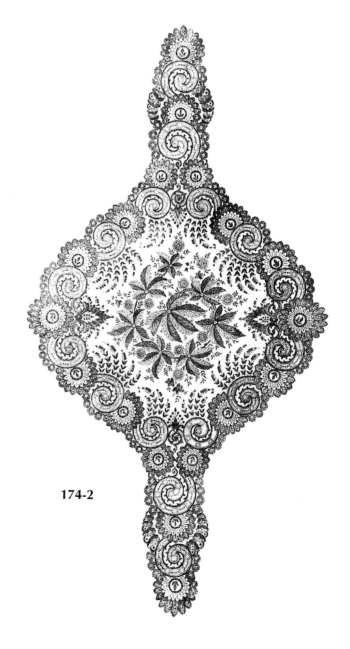

174-2

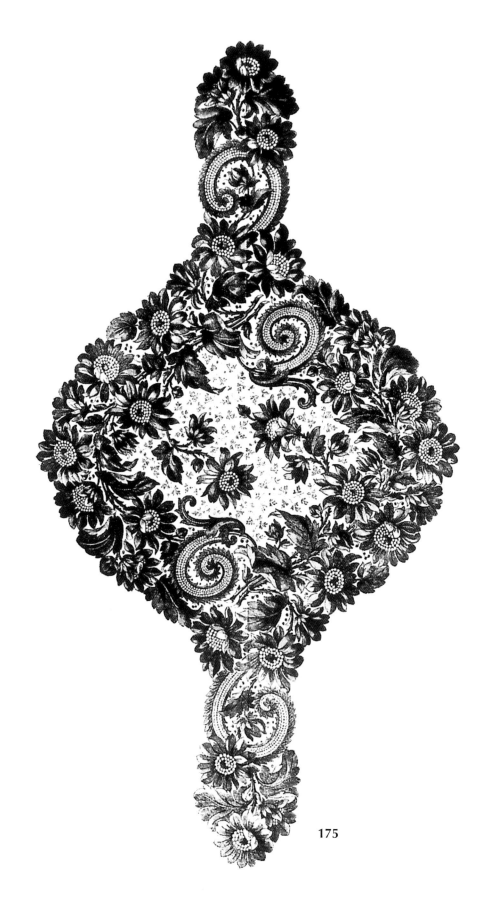

175

176-1

176-2

176-3

176-4

176-5

177-1

177-2

177-3

177-4

177-5

178-1

178-2

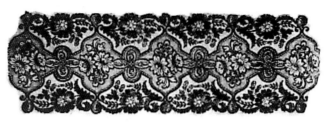

178-3

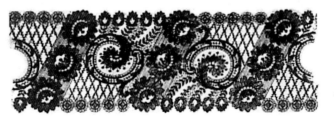

178-4

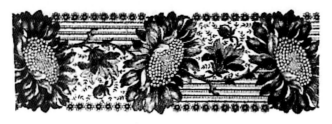

178-5

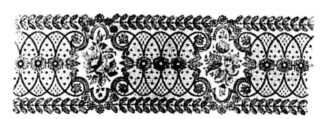

178-6

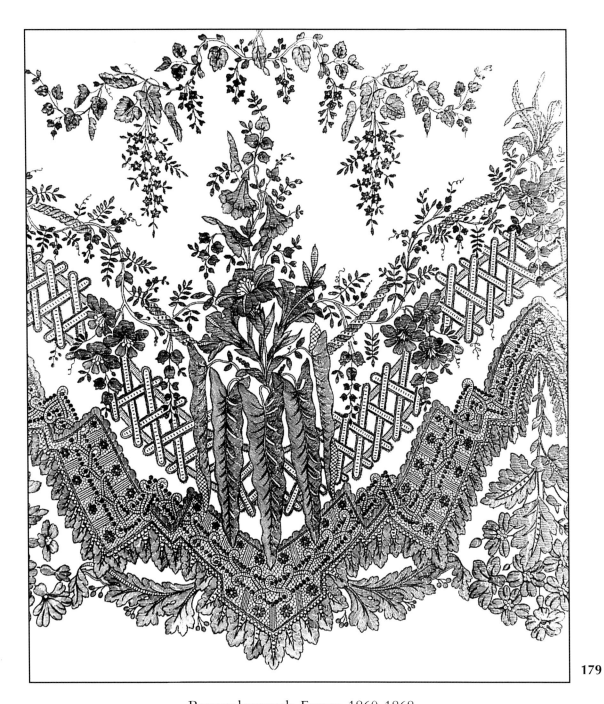

179

Bayeux lacework, France, 1860-1868.
Dentelle de Bayeux, France., 1860-1868.
Spitzen aus Bayeux, Frankreich, 1860-1868.
Кружева, Байо, Франция, 1860-1868.

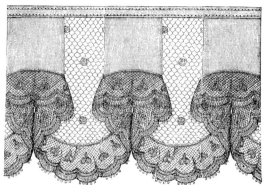

180-1

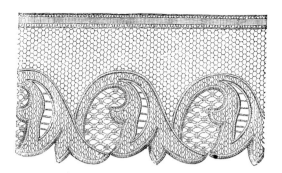

180-2

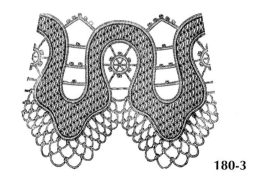

180-3

180-181:
Lacework, mid 19th century.
Dentelle, milieu du XIX^e siècle.
Spitzen, Mitte des XIX. Jahrhunderts.
Кружева, середина 19 в.

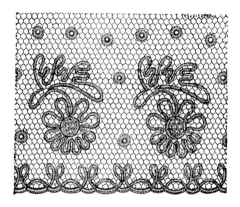

180-4

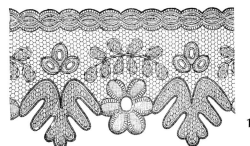

181-1

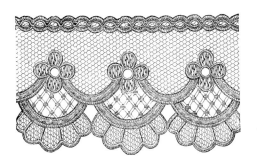

181-2

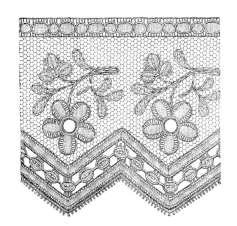

181-3

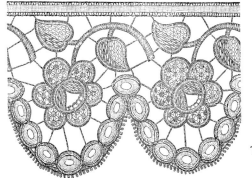

181-4

Collar, lacework,
Austria.
Col de dentelle,
Autriche.
Spitzenkragen,
Österreich.
Воротник, кружево,
Австрия.

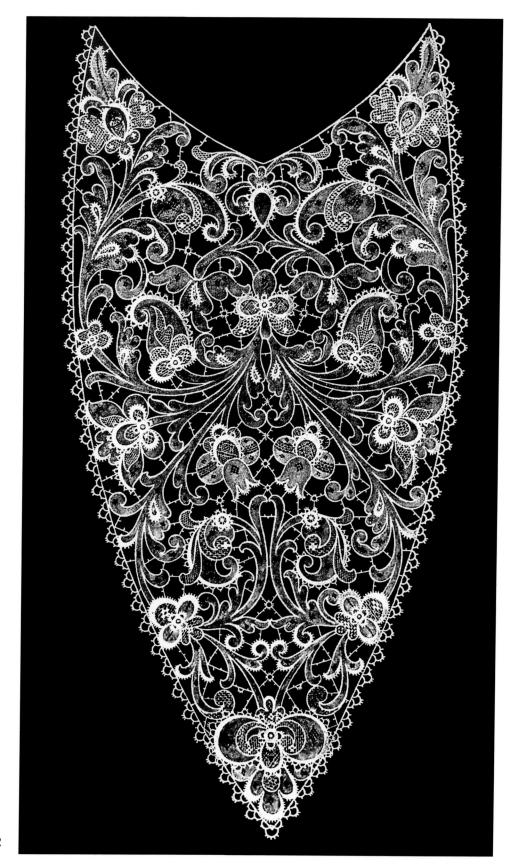

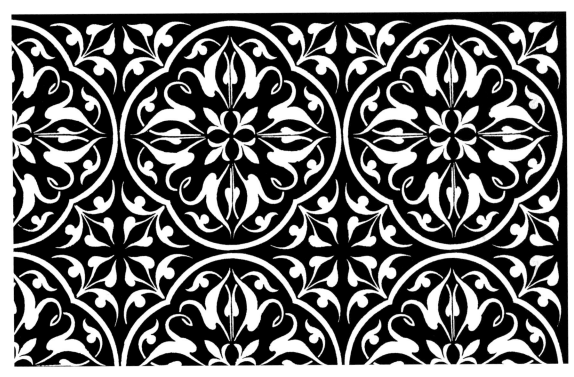

183

183-198:

Charles Cahier, Arthur Martin, *Suite aux Mélanges d'archéologie,* 1868.

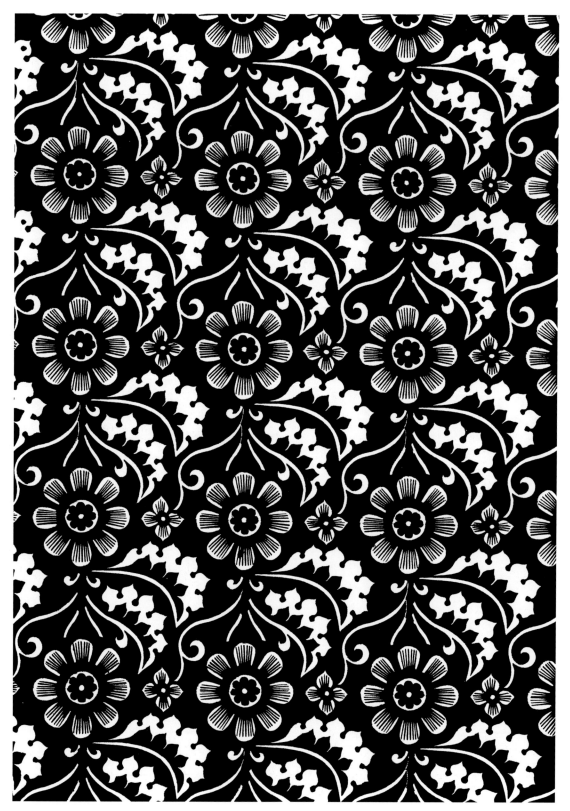

184

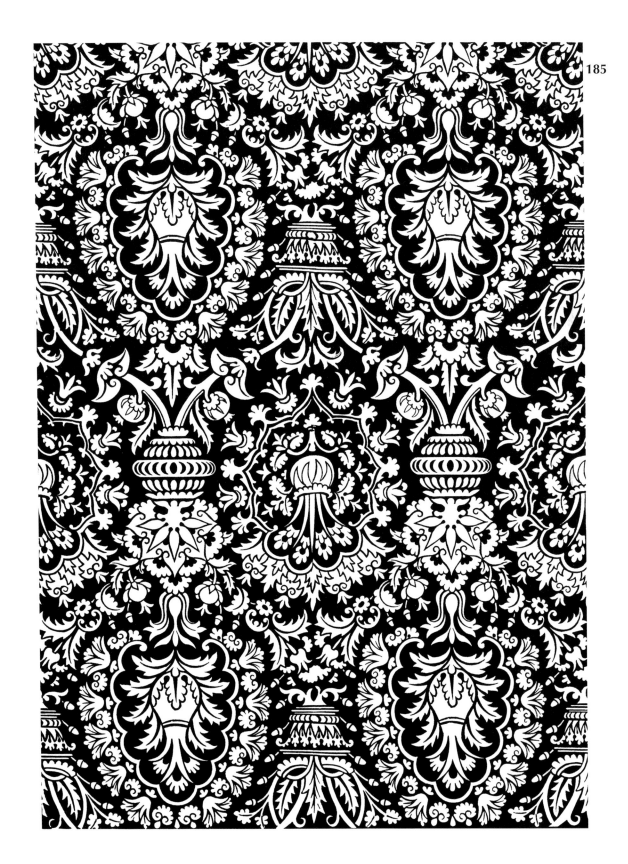

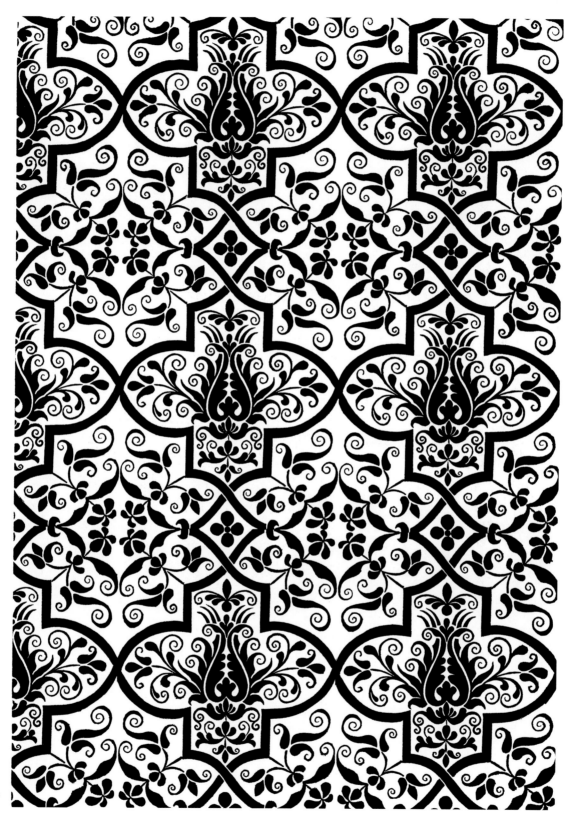

186

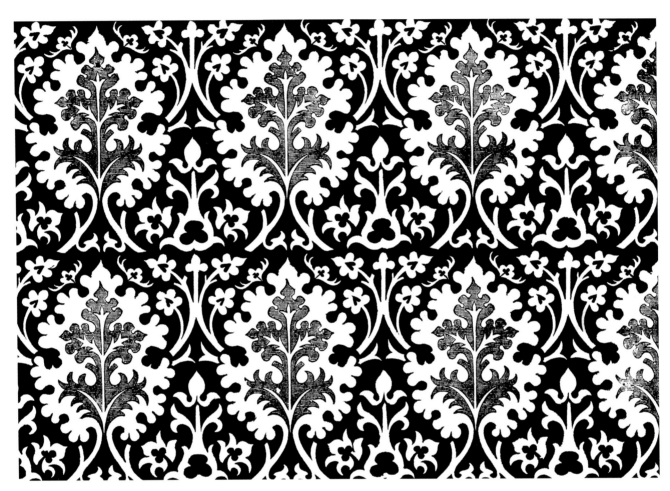

187

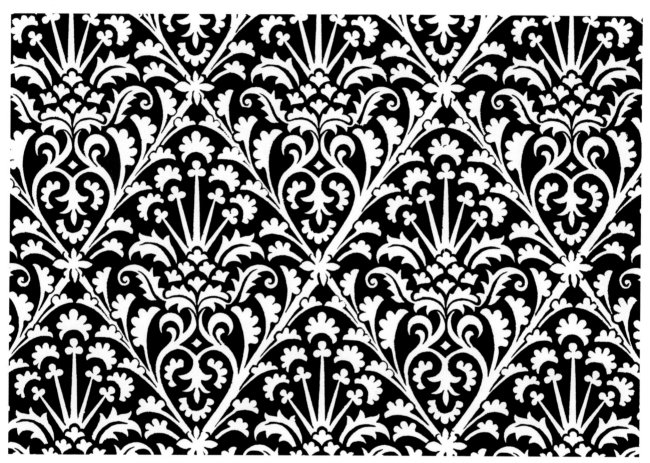

188

189

190

191

192

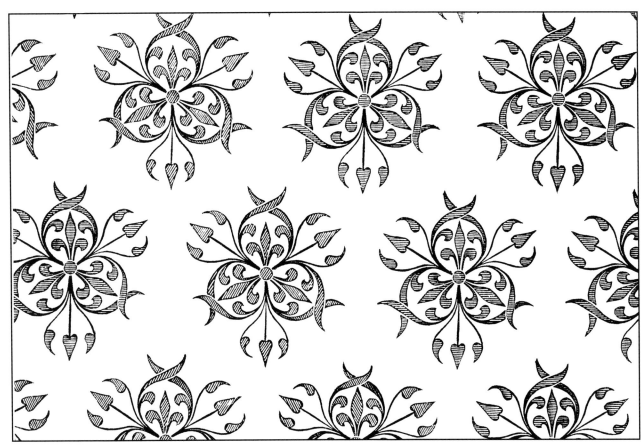

193

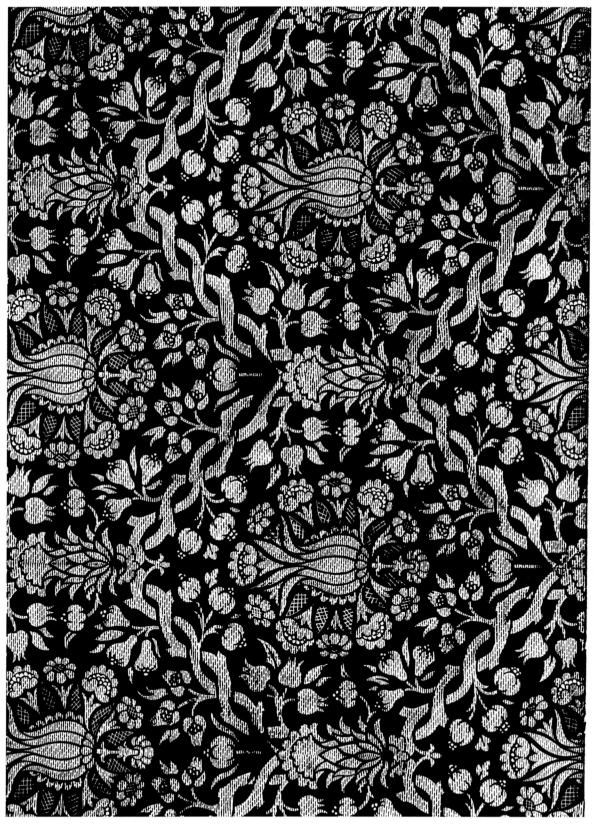

194

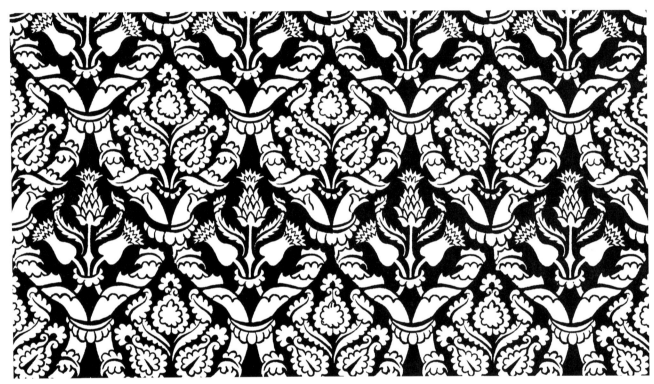

195

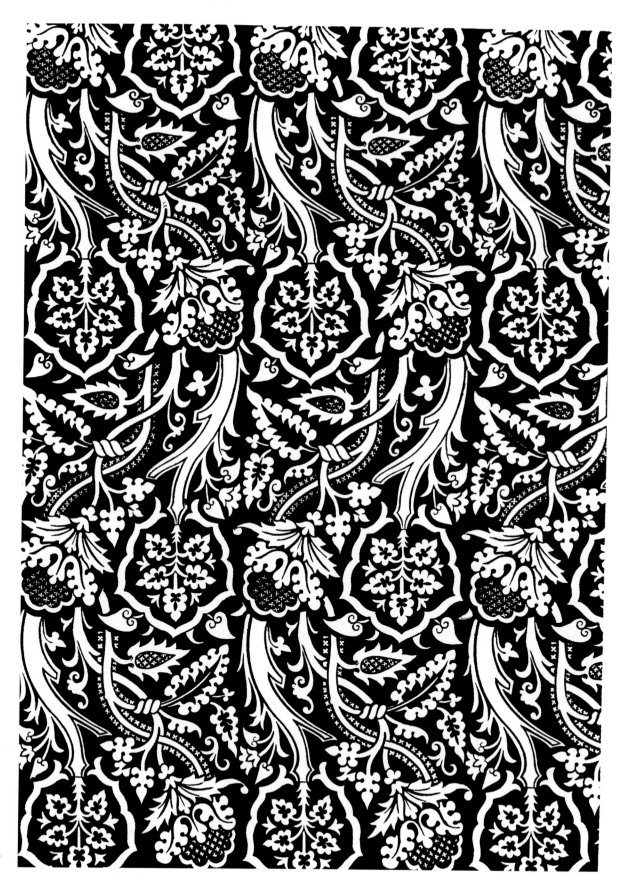

197-1

197-2

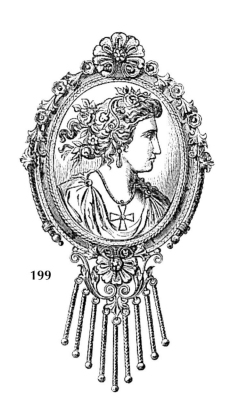

199

199:
Lecointe. Brooch, enamelled gold and brilliant, Renaissance and Romantic styles, Paris, 1855.
Lecointe. Broche en or émaillé et brillant, style romantique et Renaissance, Paris, 1855.
Lecointe. Brosche aus glänzendem emailliertem Gold, romantischer Stil und Renaissance, Paris, 1855.
Лекуант. Брошь, золото, эмаль, бриллианты, стиль Ренессанс и Романтизм, Париж, 1855.

• Jewellery•
• Bijoux •
• Schmuck •
• Ювелирные украшения •

200-1:
Necklace, enamelled gold, Etrurian style.

Collier en or émaillé de style étrusque.

Emaillierte goldene Halskette, etruskischer Stil.

Ожерелье, золото, эмаль, этрусский стиль.

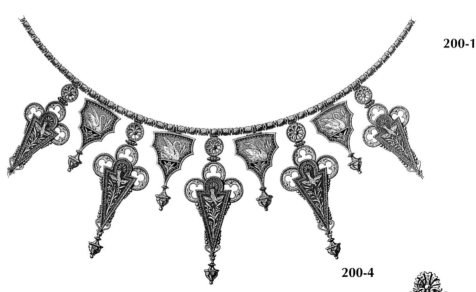

200-1

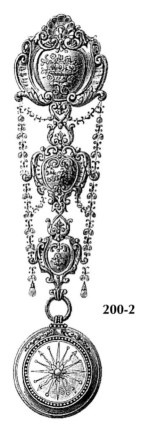

200-2

200-4:
P. Bénard. Watch chain, engraved gold, Louis XIV style, Paris, 1877.

P. Bénard. Chaîne de montre, or ciselé de style Louis XIV, Paris, 1877.

P. Bénard. Goldene Uhrkette, graviert, Stil Louis XIV, Paris, 1877.

П. Бенар. Цепочка для часов, золото, гравировка, стиль эпохи Людовика XIV, Париж, 1877.

200-4

200-2:
Watch chain, engraved gold, pearls and brilliants, Renaissance style, Paris, 1877.

Chaîne de montre, or ciselé, perles et brillants, style Renaissance, Paris, 1877.

Goldene Uhrkette, mit Gravuren und mit Perlen, Stil der Renaissance, Paris, 1877.

Цепочка для часов, золото, гравировка, жемчуг и бриллианты, стиль Ренессанс, Париж, 1877.

200-3

200-3:
V. Salvo. Comb, envraved gold, Geneva, 1873.

V. Salvo. Peigne, or ciselé, Genève, 1873.

V. Salvo. Goldener Haarkamm, graviert, Genf, 1873.

В. Сальво. Гребень, золото, гравировка, Женева, 1873.

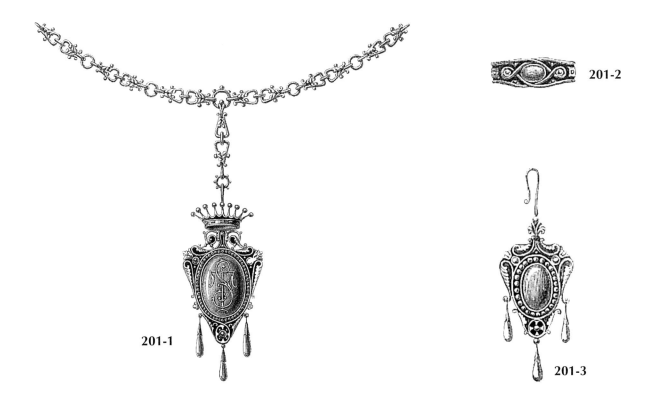

201-2

201-1

201-3

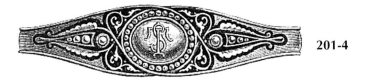

201-4

201:
R. Bonacina. Parure, engraved gold and pearls, Rome, 1877.
R. Bonacina. Parure, or ciselé et perles, Rome, 1877.
R. Bonacina. Goldenes Schmuckset, graviert und mit Perlen, Rom, 1877.
Р. Боначина. Парюра, золото, гравировка, жемчуг, Рим, 1877.

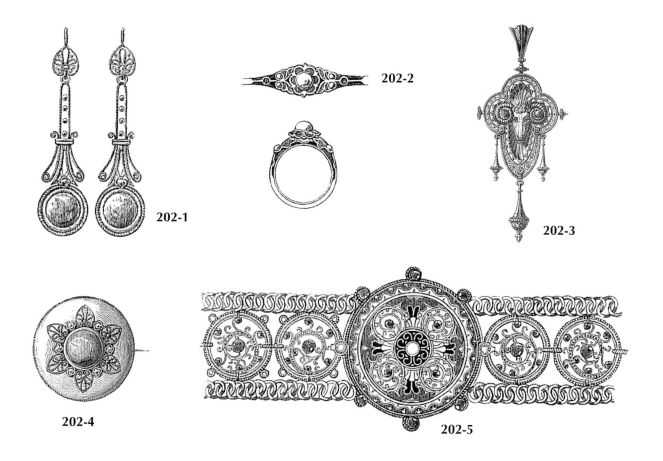

202-1, 202-2:

Ring and earrings, enamelled gold and amethyst, Roman style.

Bague et boucle d'oreille, or émaillé et améthyste, de style romain.

Ring und Ohrringe, emailliertes Gold mit Amethysten, romanischer Stil.

Кольцо и серьги, золото, эмаль, аметисты, римский стиль.

202-3:

Charm, engraved gold, Rome, 1870.

Breloque, or ciselé, Rome, 1870.

Goldener Anhänger, graviert, Rom, 1870.

Амулет, золото, гравировка, Рим, 1870.

202-4:

Brooch, engraved and enamelled gold, Italy, 1870.

Broche, or ciselé et émaillé, Italie, 1870.

Goldene Brosche, emailliert und graviert, Italien, 1870.

Брошь, золото, гравировка, эмаль, Италия, 1870.

202-5:

Lecointe. Bracelet, enamelled gold and brilliants, Renaissance and Romantic styles, Paris, 1855.

Lecointe. Bracelet, or émaillé et brillants de style Renaissance et romantique, Paris, 1855.

Lecointe. goldenes Armband, emailliert, Renaissance und romantischer Stil, Paris, 1855.

Лекуант. Браслет, золото, эмаль, бриллианты, стиль Ренессанс и Романтизм, Париж, 1855.

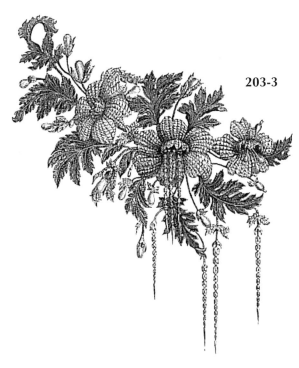

203-3

203-1:
A. Castellani. Necklace, enamelled gold, Rome, 1873.
A.Castellani. Collier, or émaillé, Rome, 1873.
A.Castellani. Goldene Halskette, emailliert, Rome, 1873.
А. Кастеллани. Ожерелье, золото, эмаль, Рим, 1873.

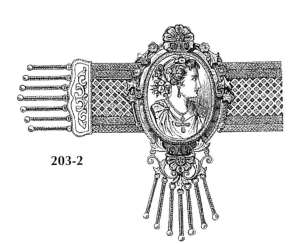

203-2

203-2:
Jewel, engraved and enamelled gold.
Bijou, or ciselé et émaillé.
Goldschmuck, emailliert
Ювелирное изделие, золото, гравировка, эмаль.

203-3:
Lemonier. Floral brooch, diamonds, emeralds and pearls, Paris, 1855.
Lemonier. Broche florale, diamants, émeraudes et perles, Paris, 1855.
Lemonier. Brosche mit Blumenmotiven, Diamanten, Smaragden und Perlen, Paris, 1855.
Лемонье. Брошь в виде цветка, бриллианты, изумруды и жемчуг, Париж, 1855.

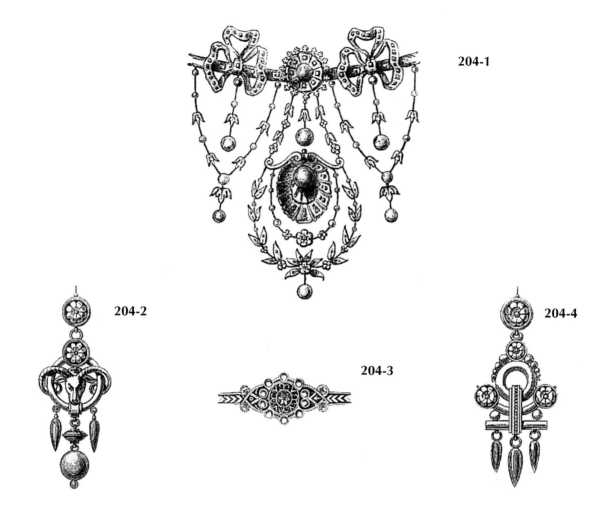

204-1

204-2

204-3

204-4

204-1:

N. A. Bellezza, Necklace, gold, silver, pearls and diamonds, Torino-Rome, 1873.

N. A. Bellezza. Collier, or, argent, perles et diamants, Turin, Rome, 1873.

N. A. Bellezza. Halskette, Gold, Silber, Perlen und Diamanten, Turin, Rome, 1873.

Н. А. Беллецца, Ожерелье, золото, серебро, жемчуг, бриллианты, Турин-Рим, 1873.

204-2, 204-4:

Charms, enamelled gold, Rome, 1870.

Breloques, or émaillé, Rome, 1870.

Anhänger, emailliertes Gold, Rom, 1870.

Амулеты, золото, эмаль, Рим, 1870.

204-3:

Wedding ring, engraved gold, Romanesque style.

Bague de mariage, or ciselé, de style roman.

Ehering, graviertes Gold, romanischer Stil.

Обручальное кольцо, золото, гравировка, Романский стиль.

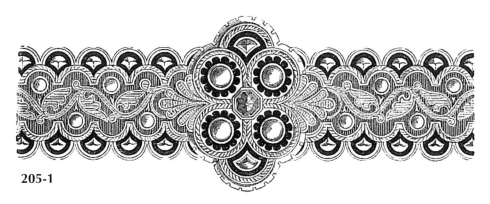

205-1

205-1:
Bracelet, gold, Romanesque style.
Bracelet en or de style roman.
Goldarmband, romanischer Stil.
Золотой браслет, Романский стиль.

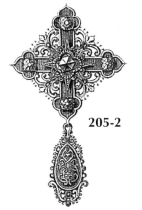

205-2

205-2:
Lecointe. Brooch, enamelled gold and brilliants, Renaissance and Romantic styles, Paris, 1855.
Lecointe. Broche en or émaillé et brillants de style Renaissance et romantique, Paris, 1855.
Lecointe. Brosche, emailliertes Gold, Renaissance und romantischer Stil, Paris, 1855.
Лекуант. Брошь, золото, эмаль и бриллианты, стиль Ренессанс и Романтизм, Париж, 1855.

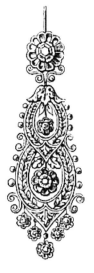

205-4

205-3:
Brooch, silver, pearls and brilliants, Italy, 1870.
Broche en argent, perles et brillants, Italie, 1870.
Brosche aus Silber, Perlen und Brillanten. Italien, 1870.
Брошь, серебро, жемчуг и бриллианты, Италия, 1870.

205-3

205-4:
Charm, gold.
Breloque en or.
Anhänger aus Gold.
Золотой амулет.

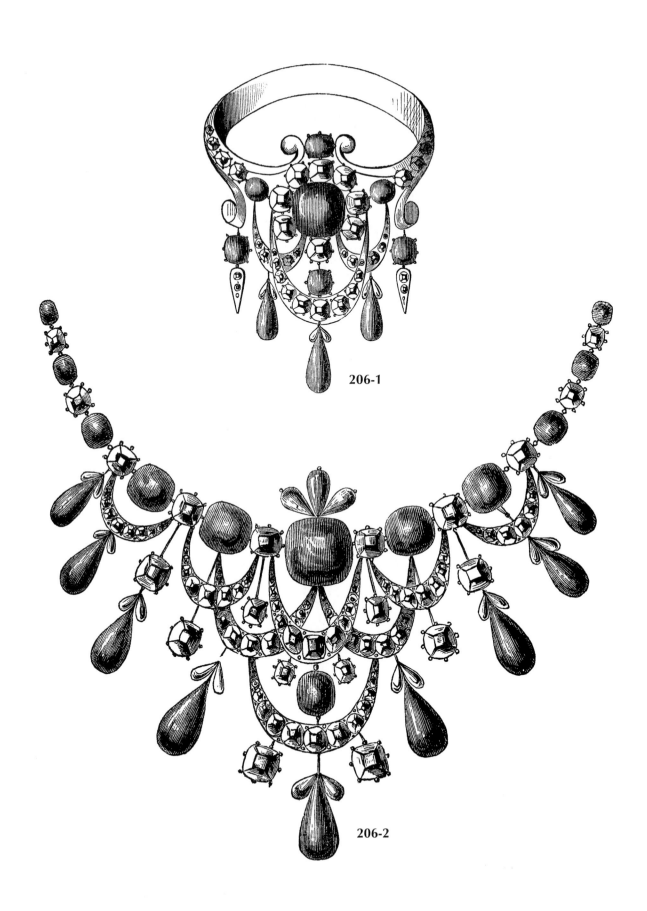

206-1

206-2

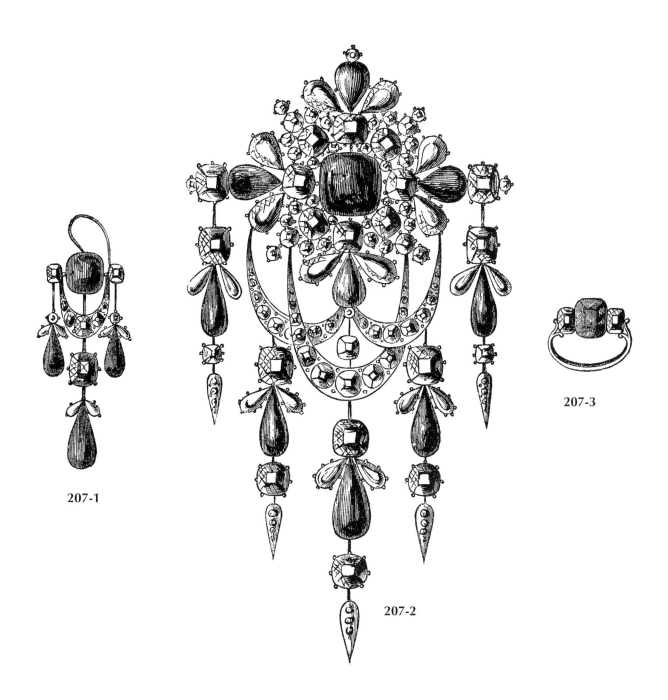

207-1

207-2

207-3

206–207:
Set of jewellery, diamonds and emeralds.
Parure de diamants et émeraudes.
Schmuckset mit Diamanten und Smaragden.
Набор ювелирных украшений, бриллианты, изумруды.

208-1 **208-2**

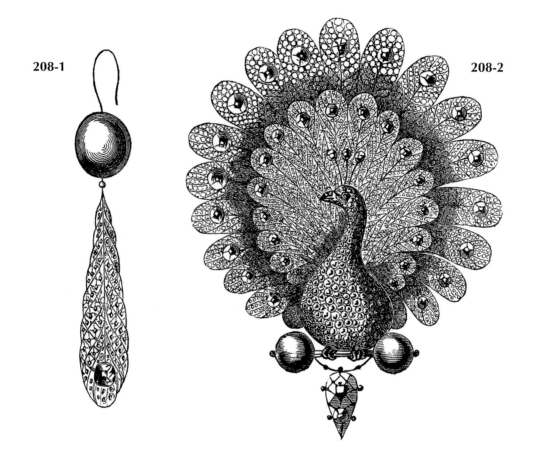

208:

Brooch and earring, diamonds, emeralds, sapphires,
opals and pearls.

Broche et boucle d'oreille de diamants, émeraudes,
saphirs, opales et perles.

Brosche und Ohrringe mit Diamanten, Smaragden,
Saphiren, Opalen und Perlen.

Брошь и серьги, бриллианты, изумруды, сапфиры,
опалы и жемчуг.

209-1

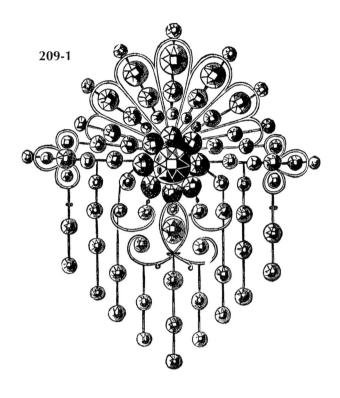

209:
Brooch and earring, diamonds.
Broche et boucle d'oreille de diamants.
Brosche und Ohrringe mit Diamanten.
Брошь и серьги с бриллиантами.

209-2

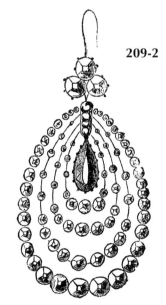

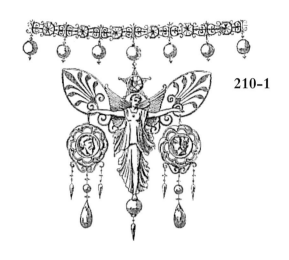

210-1

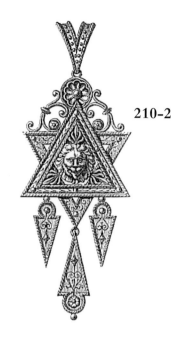

210-2

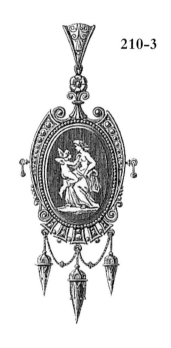

210-3

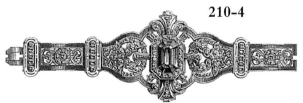

210-4

210-1:
P. Bénard. Necklace, gold, pearls and brilliants, Paris, 1877.
P. Bénard. Collier en or, perles et brillants, Paris, 1877.
P. Bénard. Goldhalskette mit Perlen und Brillanten, Paris, 1877.
П. Бенар. Ожерелье, золото, жемчуг и бриллианты, Париж, 1877.

210-2, 210-3:
Charms, engraved gold, Rome, 1870.
Breloque en or ciselé, Rome, 1870.
Anhänger, graviertes Gold, Rom, 1870.
Амулеты, золото, гравировка, Рим, 1870.
210-4:
Lecointe. Bracelet, enamelled gold and brilliants, Renaissance and Romantic styles, Paris, 1855.
Lecointe. Bracelet en or émaillé et brillants de style Renaissance et romantique, Paris, 1855.
Lecointe. Armband, emailliertes Gold, Renaissance und romantischer Stil, Paris, 1855.
Лекуант. Браслет, эмаль, золото, бриллианты, стиль Ренессанс и Романтизм, Париж, 1855.

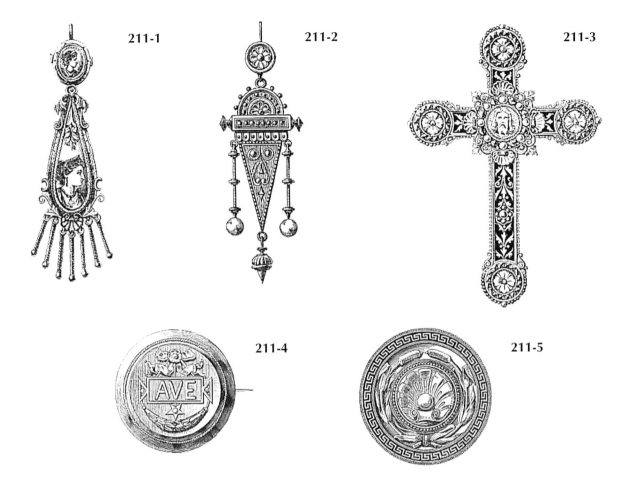

211-1, 211-2:
Charms, antique style, Rome, 1870-1880.
Breloques de style antique, Rome, 1870-1880.
Anhänger, antiker Stil, Rom, 1870-1880.
Амулеты в античном стиле, Рим, 1870-1880.

211-3:
Crucifix, enamelled gold.
Crucifix, orfèvrerie émaillée.
Kruzifix, emaillierte Goldschmiedekunst.
Распятие, эмаль, золото.

211-4, 211-5:
Brooches, engraved and enamelled gold, Italy, 1870.
Broches en or ciselé et émaillé, Italie, 1870.
Brosche, graviertes und emailliertes Gold, Italien, 1870.
Броши, золото, эмаль, гравировка, Италия, 1870.

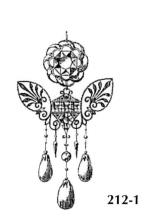

212-1

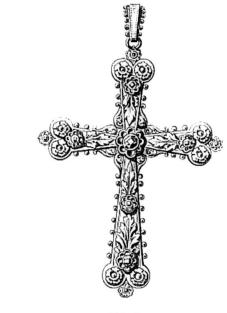
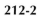

212-2

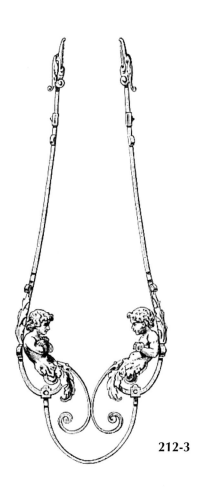

212-3

212-1:
P. Bénard. Earring, gold, pearls
and brilliants, Paris, 1877.
P. Bénard. Boucle d'oreille en or,
perles et brillants, Paris, 1877.
P. Bénard. Goldene Ohrringe,
Perlen und Brillanten, Paris,
1877.
П. Бенар. Серьги, золото,
жемчуг, бриллианты, Париж,
1877.
212-2, 212-3:
Golden jewels.
Bijoux en or.
Goldschmuck.
Золотые ювелирные украшения.

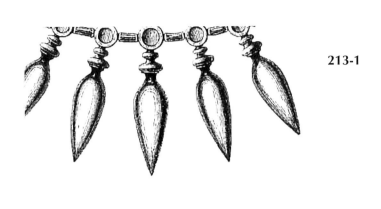

213-1

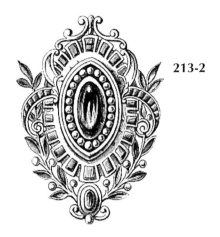

213-2

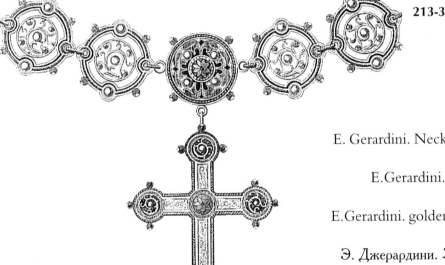

213-3

213-1:
E. Gerardini. Necklace, gold, Romanesque style, Rome, 1873.
E.Gerardini. Collier en or de style roman, Rome, 1873.
E.Gerardini. goldene Halskette, romanischer Stil, Rom, 1873.
Э. Джерардини. Золотое ожерелье в романском стиле, Рим, 1873.

213-2:
Brooch, gold and precious stones.
Broche en or et pierres précieuses.
Goldene Brosche mit Edelsteinen.
Золотая брошь с драгоценными камнями.

213-3:
Necklace with cross, engraved gold, Romanesque style.
Collier avec croix de style roman, or ciselé.
Kette mit Kreuz, romanischer Stil, graviertes Gold.
Ожерелье с крестиком, золото, гравировка, романский стиль.

214-1:
Charm, engraved gold,
Rome, 1870.
Breloque en or ciselé,
Rome, 1870.
goldener Anhänger, graviert,
Rom, 1870.
Амулет, золото, гравировка,
Рим, 1870.

214-2:
Watch chain, engraved and
enamelled gold, Italy, 1870.
Chaîne de montre en or ciselé et
émaillé, Italie, 1870.
Goldene Uhrkette, graviert und
emailliert, Italien, 1870.
Цепочка для часов, золото,
гравировка, эмаль, Италия, 1870.

214-3:
Charm, antique style, Rome,
1870-1800.
Breloque de style antique, Rome,
1870-1880.
Anhänger, antiker Stil, Rom,
1870-1880.
Амулет в античном стиле, Рим,
1870-1800.

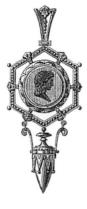

214-1

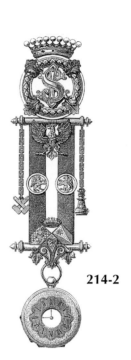

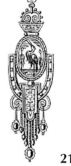

214-3

214-2

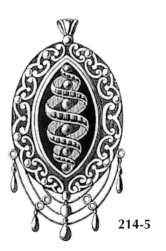

214-5

214-4, 214-5:
Charms, engraved gold.
Breloques en or ciselé.
Anhänger aus graviertem Gold.
Амулеты, золото, гравировка.

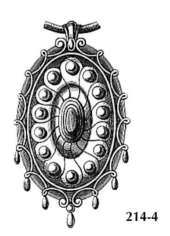

214-4

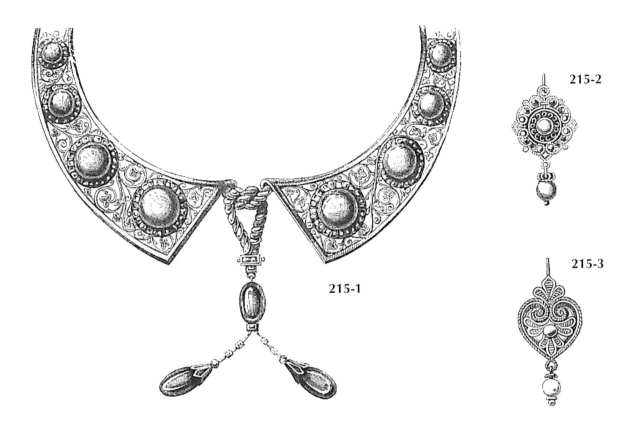

215-2

215-3

215-1

215-1:

N. A. Bellezza. Necklace, gold, pearls and brilliants, Torino-Rome, 1873.

N.A.Bellezza. Collier en or, perles et brillants, Turin-Rome, 1873.

N.A.Bellezza, Halskette aus Gold, Perlen und Brillanten, Turin- Rom, 1873.

Н.А. Беллецца. Золотое ожерелье, жемчуг, бриллианты, Турин-Рим, 1873.

215-2:

Earring, enamelled gold, Romanesque style.

Boucle d'oreille en or ciselé, de style roman.

Goldene Ohrringe, graviert, romanischer Stil

Серьги, золото, эмаль, романский стиль.

215-3:

Earring, enamelled gold and amethyst, Romanesque style.

Boucle d'oreille en or émaillé et améthyste, de style roman.

Ohrringe, emailliertes Gold und mit Amethysten, romanischer Stil.

Серьги, золото, эмаль, аметисты, романский стиль.

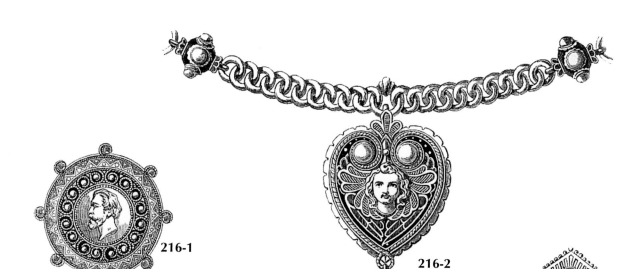

216-1:

Brooch, engraved gold, Romanesque style.
Broche en or ciselé, de style roman.
Brosche, graviertes Gold, romanischer Stil.
Брошь, золото, гравировка, романский стиль.

216-2:

Necklace, enamelled gold and amethyst, Romanesque style.
Collier en or émaillé et améthyste, de style roman.
Halskette aus Gold, emailliert und mit Amethystes, romanischer Stil.
Ожерелье из золота, эмаль, аметисты, романский стиль.

216-3, 216-4:

Charms, antique style, Rome, 1870-1880.
Breloques de style antique, Rome, 1870-1880.
Anhänger, antiker Stil, Rom, 1870-1880.
Амулеты в античном стиле, Рим, 1870-1880.

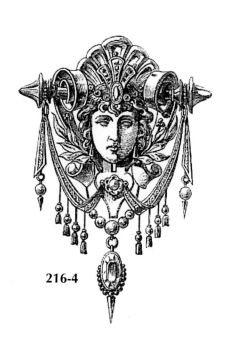

216-3

216-4

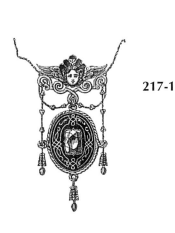

217-1

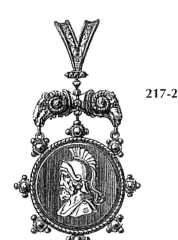

217-2

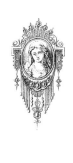

217-3

217-4

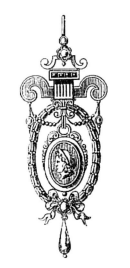

217-5

217-1:
Lecointe. Charm, enamelled gold and brilliants, Renaissance and Romantic styles, Paris, 1855.
Lecointe. Breloque en or émaillé et brillants de style Renaissance et romantique, Paris, 1855.
Lecointe. Anhänger aus emailliertem Gold und mit Brillanten, Renaissance und romantischer Stil, Paris, 1855.
Лекуант. Амулет, золото, бриллианты, эмаль, стиль Ренессанс и Романтизм, Париж, 1855.

217-2:
Charm, engraved gold, Rome, 1870.
Breloque en or ciselé, Rome, 1870.
Goldener Anhänger, graviert, Rom, 1870.
Амулет, золото, гравировка, Rome, 1870.

217-3, 217-4:
Charms, engraved gold.
Broches en or ciselé.
Goldene Broschen, graviert.
Амулеты, золото, гравировка.

217-5:
Charm, antique style, Rome, 1870-1880.
Breloque de style antique, Rome, 1870-1880.
Anhänger , antiker Stil, Rom, 1870-1880.
Амулет в античном стиле, Рим, 1870-1880.

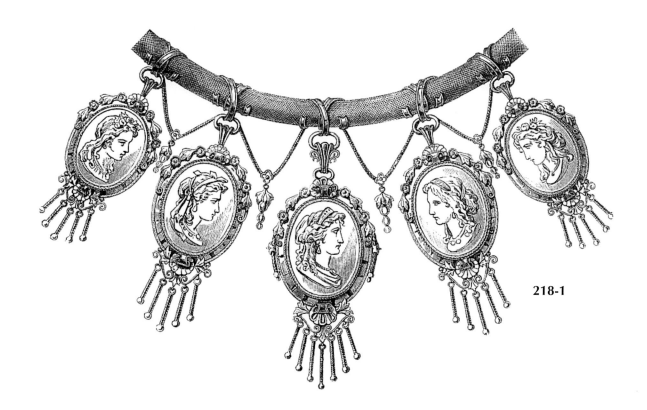

218-1:
Necklace, engraved and enamelled gold, Italy, 1870.
Collier en or ciselé et émaillé, Italie, 1870.
Goldene Halskette, graviert und emailliert, Italien, 1870.
Ожерелье, золото, эмаль, гравировка, Италия, 1870.

218-2:
Bracelet, engraved gold.
Bracelet en or ciselé.
Goldenes Armband, graviert.
Браслет, золото, гравировка.

218-3:
Earrings, engraved and enamelled gold, Italy, 1870.
Boucles d'oreilles en or ciselé et émaillé, Italie, 1870.
Goldene Ohrringe, emailliert, Italien, 1870.
Серьги, золото, эмаль, гравировка, Италия, 1870.

218-2

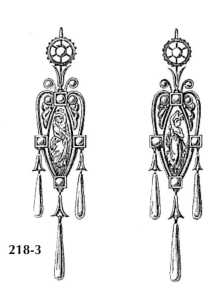

218-3

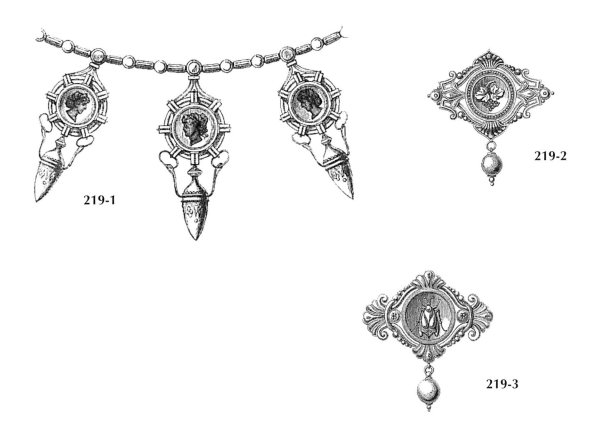

219-1 **219-2** **219-3**

219-1:
E. Gerardini. Necklace, gold and onyx, Rome, 1873.
E.Gerardini. Collier en or et onyx, Rome,1873.
E.Gerardini. goldene Halskette, mit Onyxen, Rom,1873.
Э. Джерардини. Золотое ожерелье с ониксами, Рим, 1873.

219-2, 219-3:
Brooches, enamelled gold, Rome, 1870.
Broches en or émaillé, Rome, 1870.
Goldene Broschen, emailliert, Rom, 1870.
Броши, золото, эмаль, Рим, 1870.

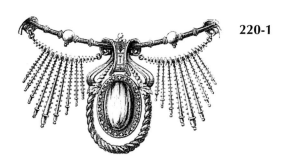

220-1

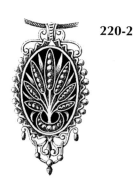

220-2

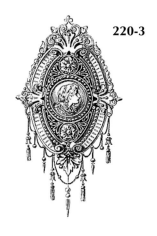

220-3

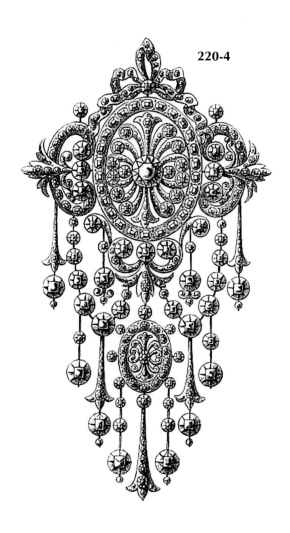

220-4

220-1:

N.A. Bellezza, Necklace, gold, Egyptian style,
Torino-Rome, 1873.

N.A. Bellezza. Collier en or de style égyptien,
Turin-Rome, 1873.

N.A. Bellezza. goldene Halskette, ägyptischer Stil,
Turin-Rom, 1873.

N.A. Беллецца, Золотое ожерелье в египетском стиле,
Турин-Рим, 1873.

220-2:

Charm, engraved gold.

Breloque en or ciselé.

Goldener Anhänger, graviert.

Амулет, золото, гравировка.

220-3, 220-4:

Brooches, engraved gold.

Broche en or ciselé.

Goldene Brosche, graviert.

Броши, золото, гравировка.

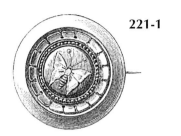

221-1

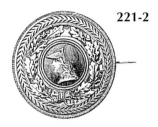

221-2

221-3

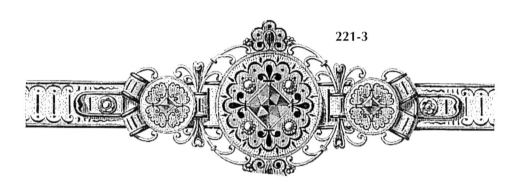

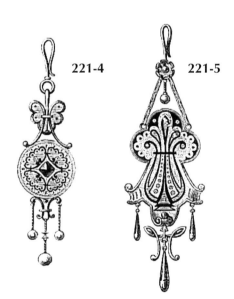

221-4 **221-5**

221-1, 221-2:
Brooches, engraved and enamelled gold, Italy, 1870.
Broches en or ciselé et émaillé, Italie, 1870.
Goldene Broschen, graviert und emailliert, Italien, 1870.
Броши, золото, эмаль, гравировка, Италия, 1870.

221-3:
Bracelet, engraved and enamelled gold, Italy, 1870.
Bracelet en or ciselé et émaillé, Italie, 1870.
Goldenes Armband, graviert und emailliert, Italien, 1870.
Браслет, золото, эмаль, гравировка, Италия, 1870.

221-4, 221-5:
Earrings, engraved and enamelled gold, Italy, 1870.
Boucles d'oreilles en or ciselé et émaillé, Italie, 1870.
Goldene Ohrringe, graviert und emailliert, Italien, 1870.
Серьги, золото, эмаль, гравировка, Италия, 1870.

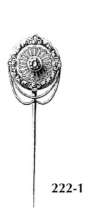

222-1

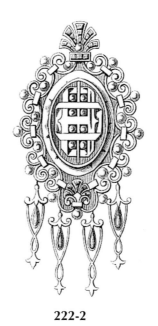

222-2

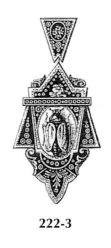

222-3

222-1:
Brooch.
Broche.
Brosche.
Брошь.

222-2, 222-4:
Charms.
Breloques.
Anhänger.
Амулеты.

222-3:
Brooch, antique style, Rome, 1870-1880.
Breloque de style antique, Rome, 1870-1880.
Anhänger, antiker Stil, Rom, 1870-1880.
Брошь в античном стиле, Рим, 1870-1880.

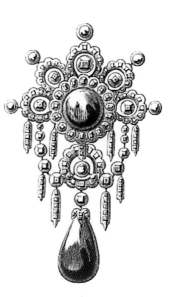

222-4

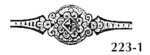

223-1

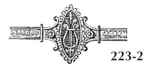

223-2

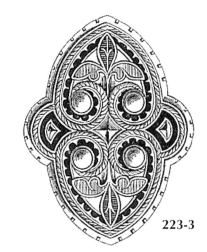

223-3

223-1, 223-2:
Rings, engraved and enamelled gold, Italy, 1870.
Bagues en or ciselé et émaillé, Italie, 1870.
Goldener Anhänger, graviert und emailliert, Italien, 1870.
Кольца, золото, эмаль, гравировка, Италия, 1870.

223-3:
Brooch, enamelled gold and amethyst, Romanesque style, Italy, 1870.
Broche en or émaillé et améthyste, de style roman, Italie, 1870.
Goldene Brosche, emailliert und mit Amethysten, romanischer Stil, Italien, 1870.
Брошь, золото, эмаль, аметисты, романский стиль, Италия, 1870.

223-4:
Charm.
Breloque.
Anhänger.
Амулет.

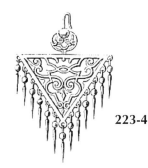

223-4

223-5:
Brooch, engraved gold, 18th century style, Paris, 1877.
Broche en or ciselé style XVIIIe siècle, Paris, 1877.
Goldene Brosche, graviert im Stil des XVIII. Jahrhundert, Paris, 1877.
Брошь, золото, гравировка, в стиле 18 века, Париж, 1877.

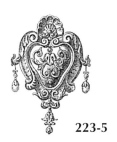

223-5

224-1

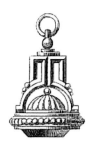

224-4

224-5

224-2

224-3

224-1:
Ring, engraved gold.
Bague en or ciselé.
Goldener Ring, graviert
Кольцо, золото, гравировка.

224-2:
Charm, engraved gold.
Breloque en or ciselé.
Goldener Anhänger, graviert .
Амулет, золото, гравировка.

224-3:
Charm, engraved and enamelled gold, Italy.
Breloque en or ciselé et émaillé, Italie.
Goldener Anhänger, graviert und emailliert, Italien.
Амулет, золото, эмаль, гравировка, Италия.

224-4:
Salvatori. Charm, Egyptian style, Rome, 1870.
Salvatori. Breloque de style égyptien, Rome, 1870.
Salvatori. Anhänger, ägyptischer Stil, Rom, 1870.
Сальватори. Амулет в египетском стиле, Рим, 1870.

224-5:
Earring, enamelled gold and amethyst, Romanesque style.
Boucle d'oreille en or émailléàtrois couleurs et améthyste,
de style roman.
Goldene Ohrringe, emailliert in drei verschiedenen Farben
und mit Amethysten, romanischer Stil .
Серьги золото, эмаль, аметисты в романском стиле.

225-1

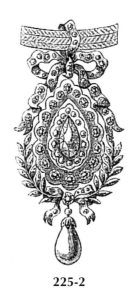

225-2

225-1:
Brooch, engraved gold.
Broche en or ciselé.
Goldene Brosche, graviert.
Брошь, золото, гравировка.

225-2:
Charm, engraved and enamelled gold, Italy, 1870.
Breloque en or ciselé et émaillé, Italie, 1870.
Goldener Anhänger, graviert und emailliert,
Italien, 1870.
Амулет, золото, эмаль, гравировка, Италия, 1870.

225-3:
Watch, engraved gold.
Montre en or ciselé.
Goldene Uhr, graviert .
Часы, золото, гравировка.

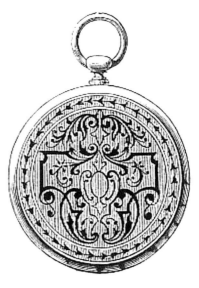

225-3

225

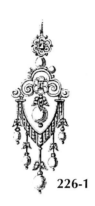

226-1

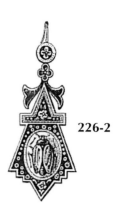

226-2

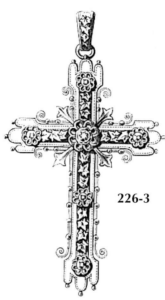

226-3

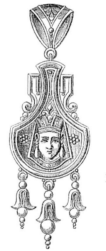

226-4

226-1, 226-3:
Charms.
Breloques.
Anhänger.
Амулеты.

226-2:
Charm, antique style, Rome, 1870-1880.
Breloque de style antique, Rome, 1870-1880.
Anhänger, antiker Stil, Rom, 1870-1880.
Амулет в античном стиле, Рим, 1870-1880.

226-4, 226-5:
Salvatori. Charms, Egyptian style, Rome, 1870.
Salvatori. Breloques de style égyptien, Rome, 1870.
Salvatori. Anhänger, ägyptischer Stil, Rom, 1870.
Сальватори. Амулеты в египетском стиле, Рим, 1870.

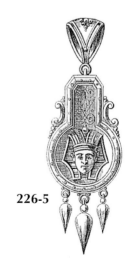

226-5

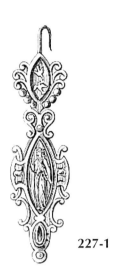

227-1

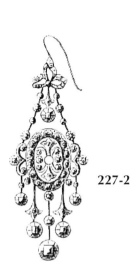

227-2

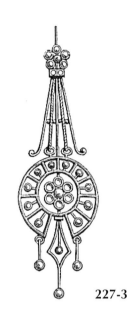

227-3

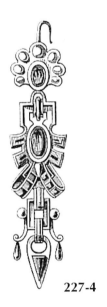

227-4

227-1, 227-2, 227-4:
Charms.
Breloques.
Anhänger.
Амулеты

227-3:
Charm, antique style, Rome, 1870–1880.
Breloque de style antique, Rome, 1870–1880.
Anhänger, antiker Stil, Rom, 1870–1880.
Амулет в античном стиле, Рим, 1870-1880.

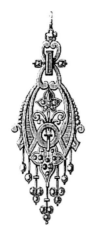

228-1

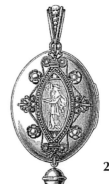

228-2

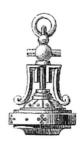

228-3

228-1:
Charm.
Breloque.
Anhänger.
Амулет.

228-2:
Charm, engraved and enamelled gold, Italy, 1870.
Breloque en or ciselé et émaillé, Italie, 1870.
Goldener Anhänger, graviert und emailliert, Italien, 1870.
Амулет, золото, эмаль, гравировка, Италия, 1870.

228-3:
Salvatori. Charm, Egyptian style, Rome, 1870.
Salvatori. Breloque de style égyptien, Rome, 1870.
Salvatori. Anhänger, ägyptischer Stil, Rom, 1870.
Сальватори. Амулет в египетском стиле, Рим, 1870.

228-4:
Cross, onyx and brilliants, Italy, 1870.
Croix en onyx et brillants, Italie, 1870.
Kreuz mit Onyxen und Brillanten, Italien, 1870.
Крест с ониксом и бриллиантами, Италия, 1870.

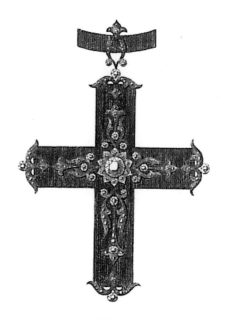

228-4

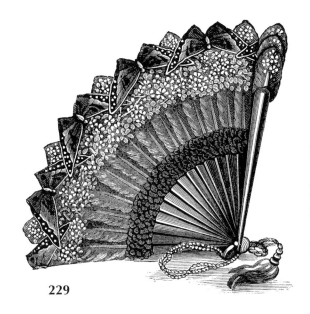

Fan, second half of
19th century.
Éventail, seconde moitié du
XIXᵉ siècle.
Fächer, zweite Hälfte des
XIX. Jahrhunderts.
Веер, вторая половина 19 в.

229

•Fashion •
• Mode •
• Мода •

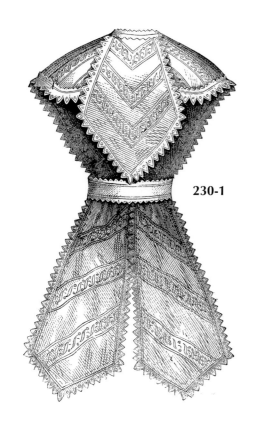

230-1

230-2

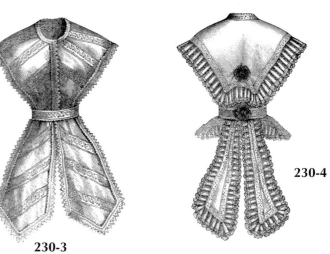

230-3

230-4

230–231:
Neck accessories.
Cols.
Umhänge.
Воротнички/повязки на шею.

Harper's Bazar, New York,
1867–1898.

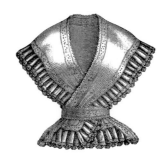

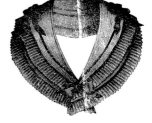

230-5

230-6

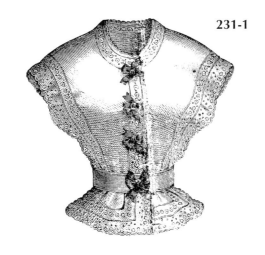

231-1

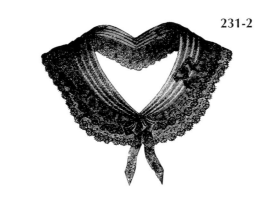

231-2

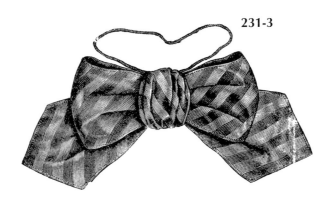

231-3

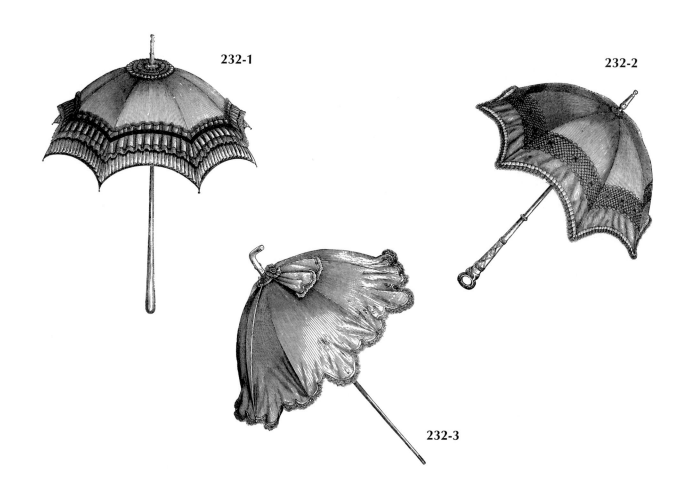

232-1

232-2

232-3

232:
Parasols.
Ombrelles.
Schirme.
Зонтики.

Harper's Bazar, New York,
1867–1898.

232-4

232-5

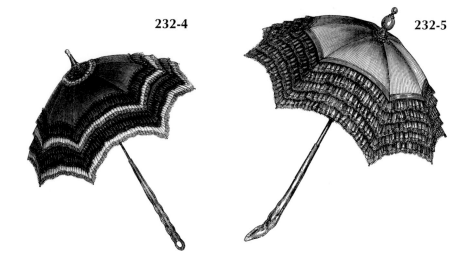

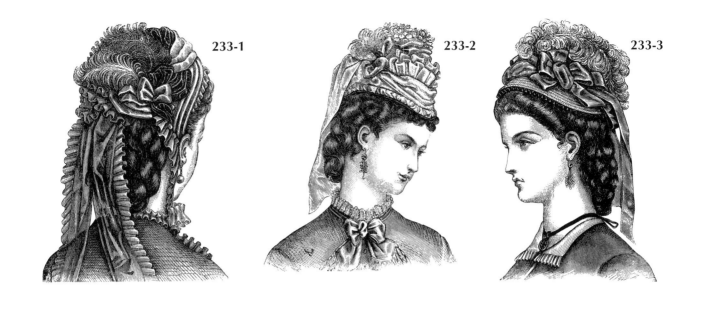

233-1

233-2

233-3

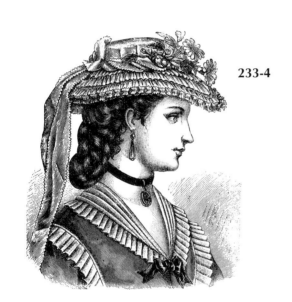

233-4

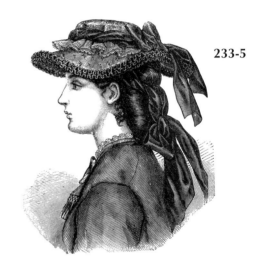

233-5

233:
Hats.
Chapeaux.
Hüte.
Шляпы.

Harper's Bazar, New York, 1867–1898.

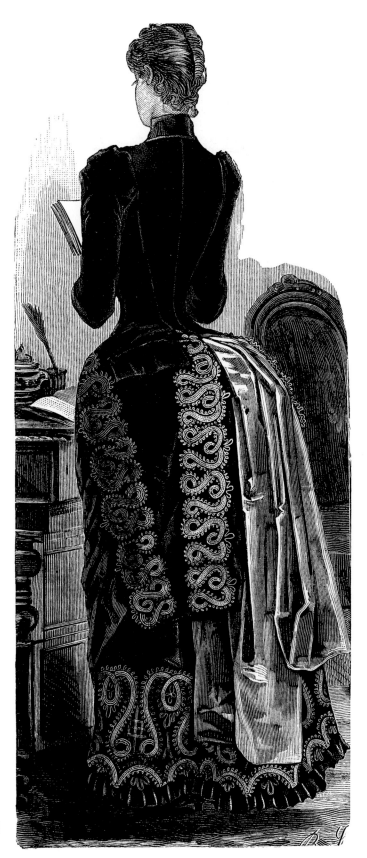

234

Widow dress,
mid 19th century.
Robe de deuil, milieu du
XIX^e siècle.
Trauerkleidung, Mitte des
19. Jahrhunderts.
Платье вдовы,
середина 19 в.

235-236:
Wraps.
Châles.
Umhänge.
Платки.

Harper's Bazar, New York,
1867–1898.

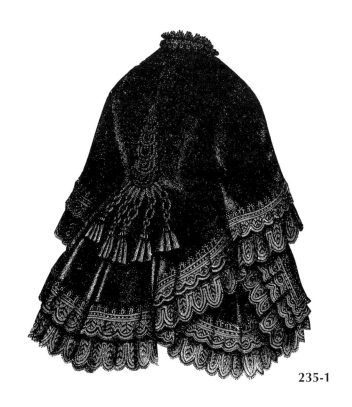

235-1

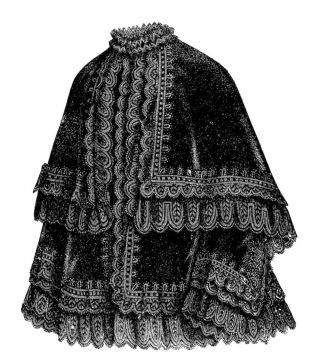

235-2

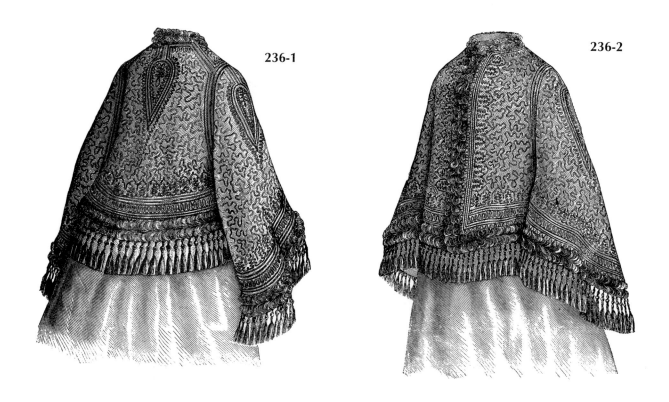

236-1

236-2

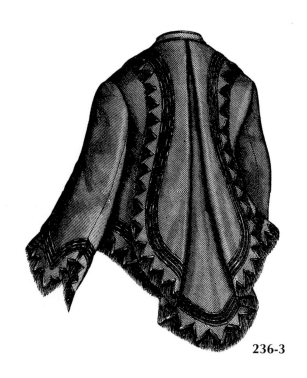

236-3

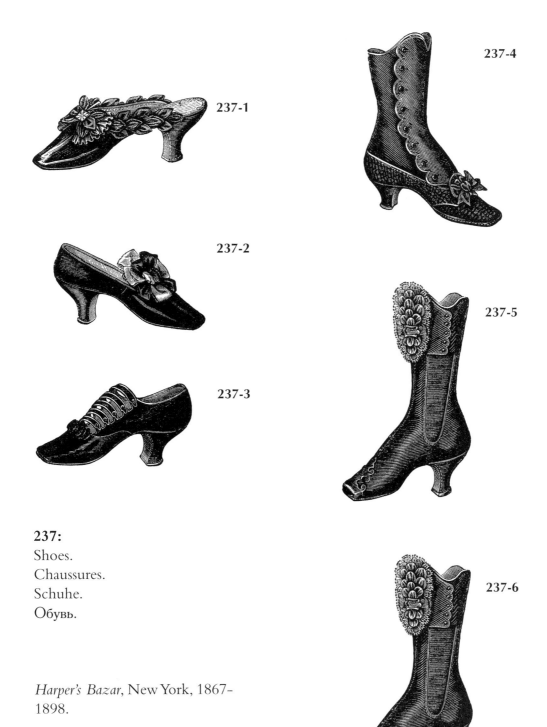

237-1

237-2

237-3

237-4

237-5

237-6

237:
Shoes.
Chaussures.
Schuhe.
Обувь.

Harper's Bazar, New York, 1867–
1898.

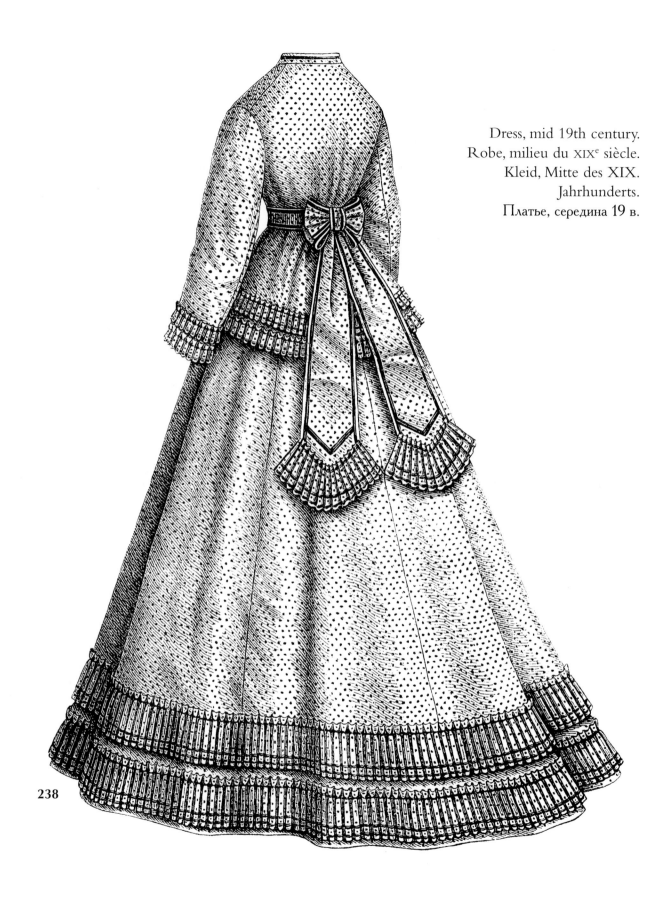

Dress, mid 19th century.
Robe, milieu du XIX^e siècle.
Kleid, Mitte des XIX.
Jahrhunderts.
Платье, середина 19 в.

238

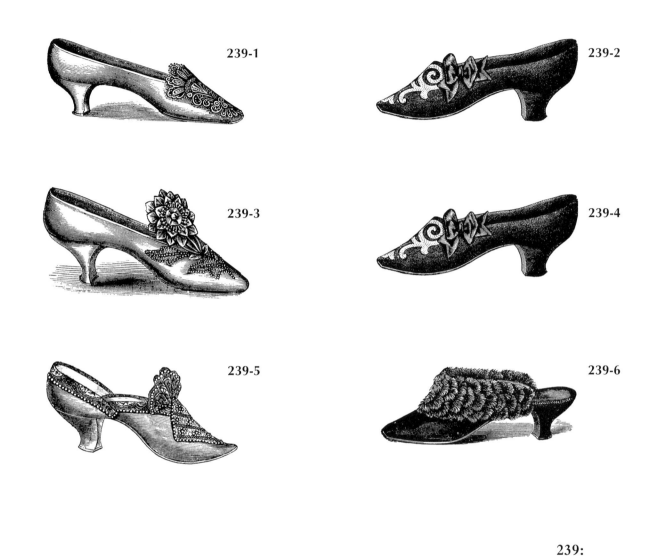

239-1

239-2

239-3

239-4

239-5

239-6

239:
Slippers.
Pantoufles.
Hausschuhe.
Туфли.

Harper's Bazar, New York, 1867–1898.

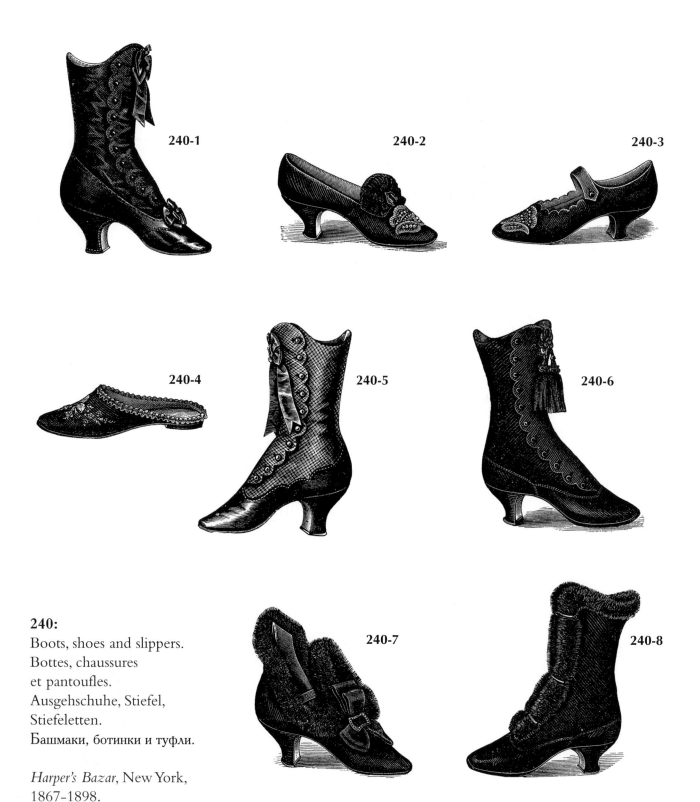

240-1

240-2

240-3

240-4

240-5

240-6

240-7

240-8

240:
Boots, shoes and slippers.
Bottes, chaussures
et pantoufles.
Ausgehschuhe, Stiefel,
Stiefeletten.
Башмаки, ботинки и туфли.

Harper's Bazar, New York,
1867–1898.

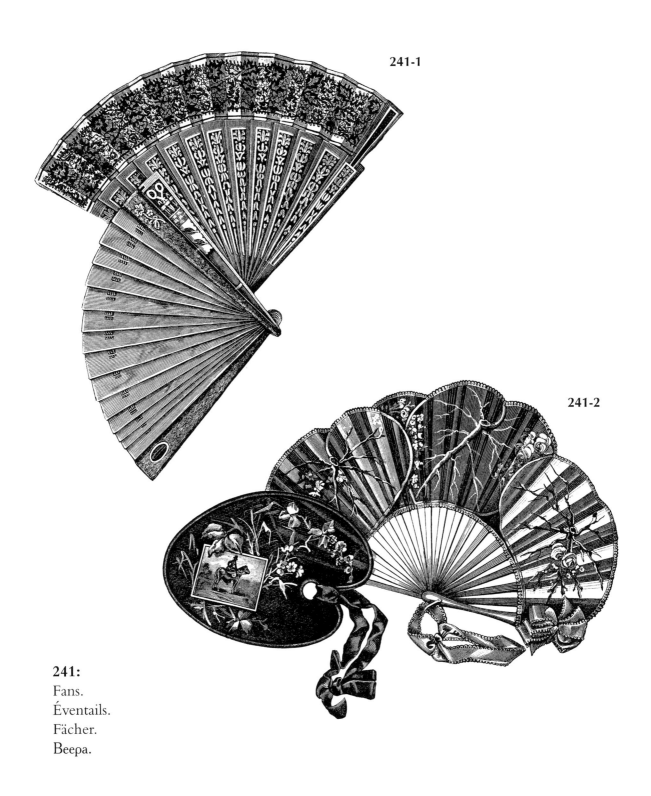

241-1

241-2

241:
Fans.
Éventails.
Fächer.
Веера.

Harper's Bazar, New
York, 1867–1898.

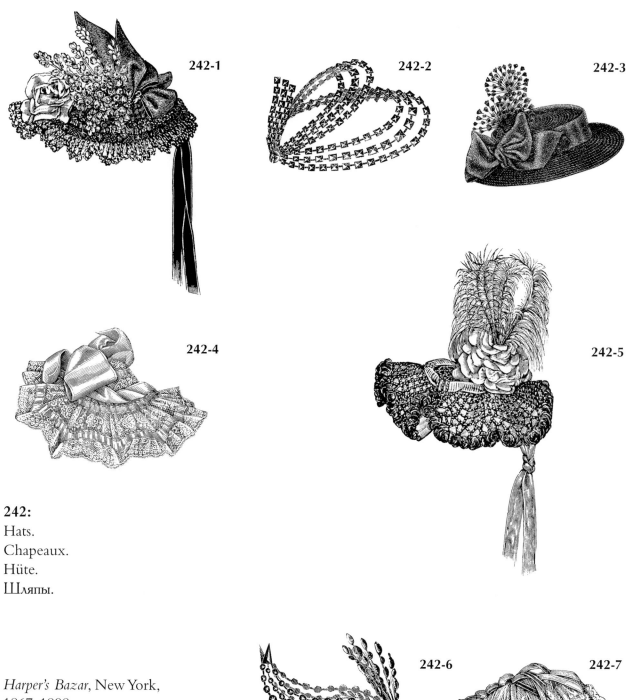

242-1

242-2

242-3

242-4

242-5

242:
Hats.
Chapeaux.
Hüte.
Шляпы.

Harper's Bazar, New York,
1867-1898.

242-6

242-7

Winterdress, mid 19th century.
Robe d'hiver, milieu du
XIX^e siècle.
Winterkleidung, Mitte des
19. Jahrhunderts.
Зимний наряд, середина 19 в.

243

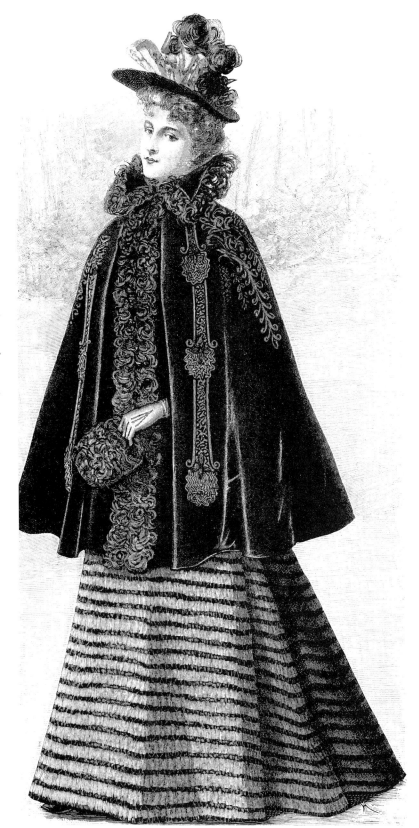

244-1

244-2

244-3

244-4

244-5

244–246:
Undergarment accessories.
Sous-vêtements.
Unterwäsche.
Нижнее белье и принадлежности.

Harper's Bazar, New York, 1867-1898.

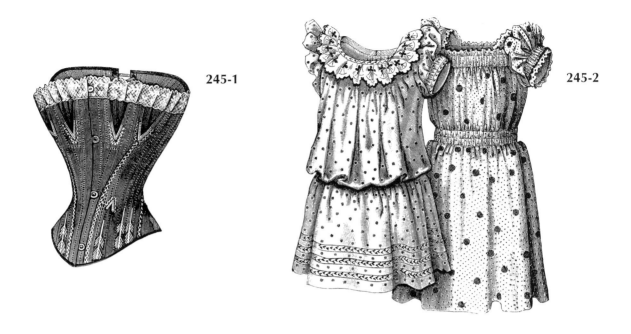

245-1

245-2

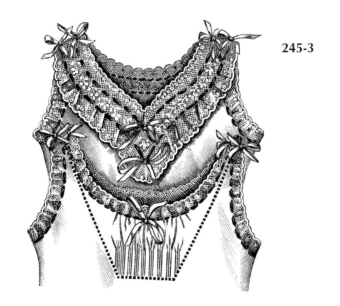

245-3

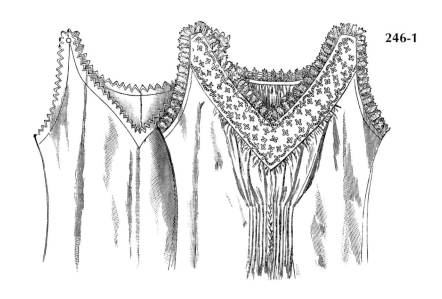

246-1

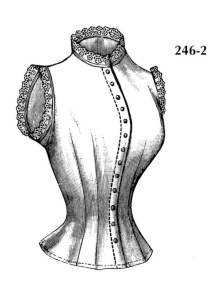

246-2

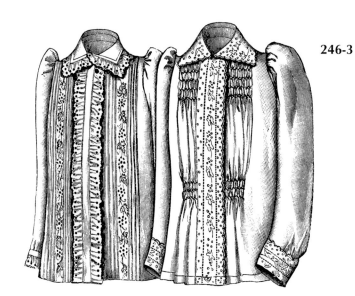

246-3

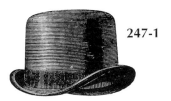

247-1

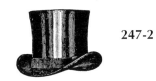

247-2

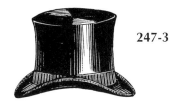

247-3

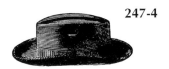

247-4

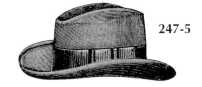

247-5

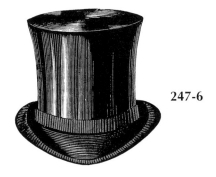

247-6

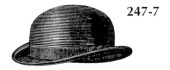

247-7

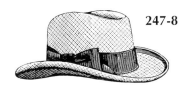

247-8

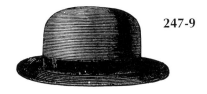

247-9

247-249:
Hats.
Chapeaux.
Hüt.
Шляпы.

Fonderie Deberny,
Paris.

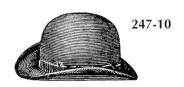

247-10

247-11

247-12

247-13

248-1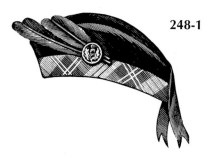

248-2

248-3

248-4

248-5

248-6

248-7

248-8

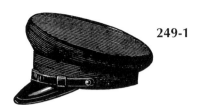 249-1

 249-2

249-3

249-4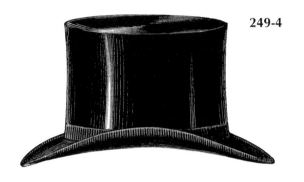

249-5

249-6

 249-7

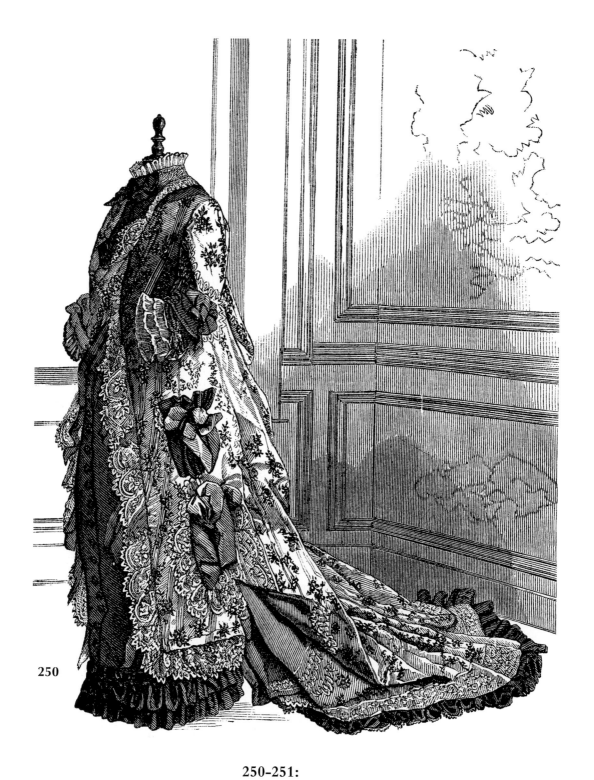

250-251:
Housecoats, second half of 19th century.
Robes d'intérieur, seconde moitié du XIX^e siècle.
Hauskleidung, zweite Hälfte des XIX. Jahrhunderts.
Женское платье, вторая половина 19 в.

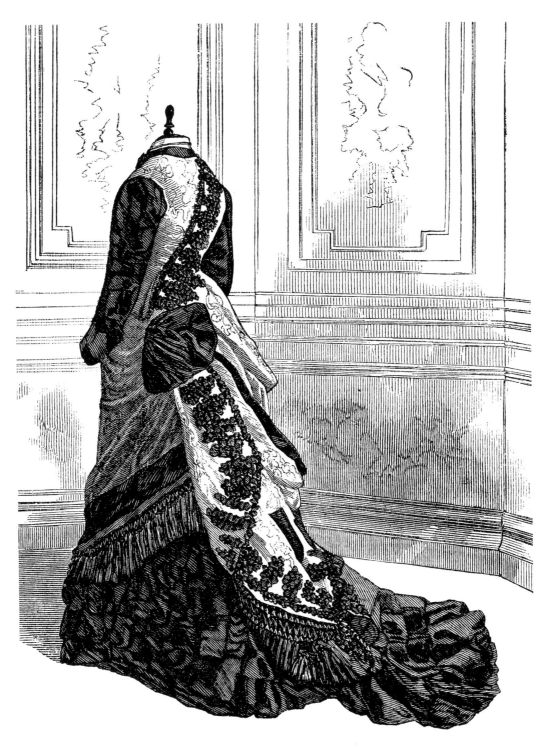

251

Dress, second half of 19th century.
Robe de promenade, seconde
moitié du XIXᵉ siècle.
Ausgangskleidung zweite Hälfte
des XIX. Jahrhunderts
Прогулочное платье, вторая
половина 19 в.

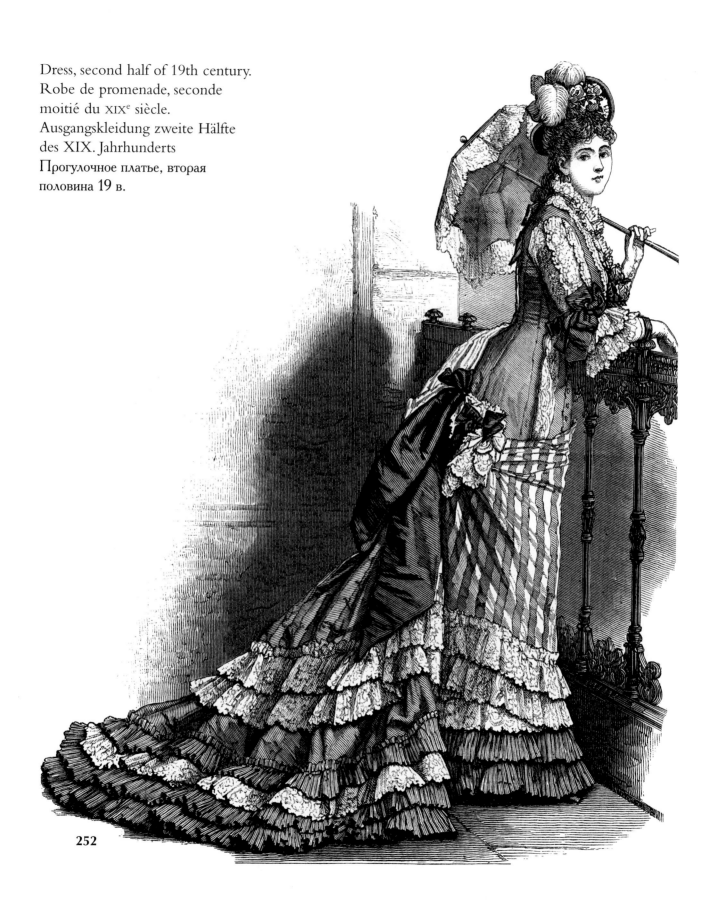

252

Wedding dress, second half of
19th century.
Robe de mariage, seconde
moitié du XIX^e siècle.
Hochzeitskleid,, zweite Hälfte
des XIX. Jahrhunderts.
Свадебное платье, вторая
половина 19 в.

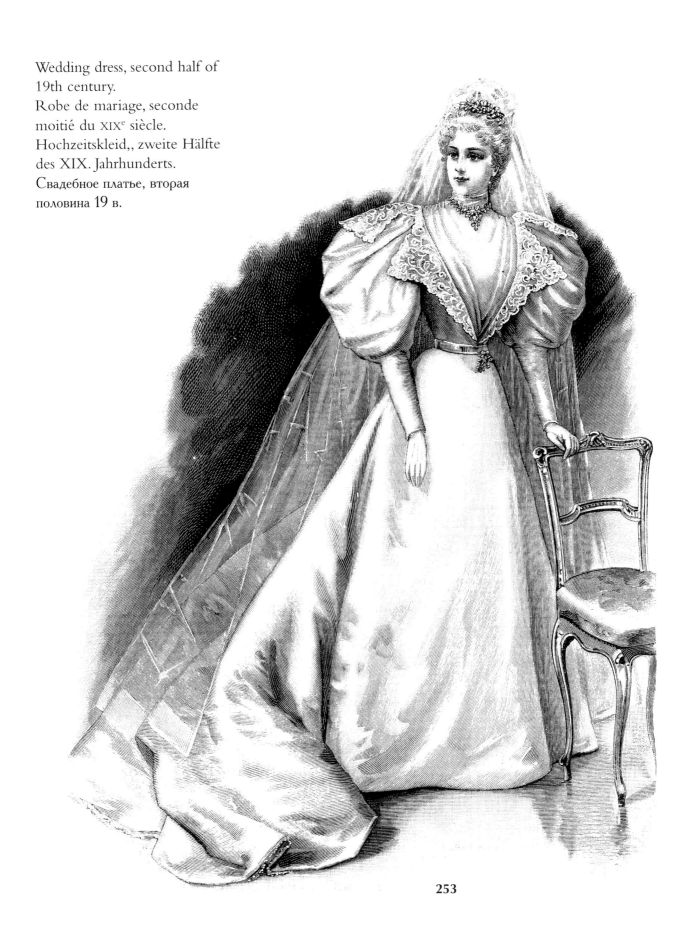

253

Horse clothing.
Couvertures pour chevaux.
Decken für Pferde.
Попона.

Moseman's Illustrated Guide for Purchasers of Horse Furnishing Goods, New York, n.d.

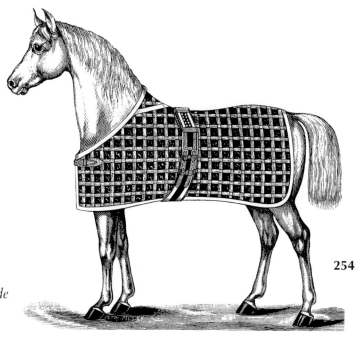

254

• Horseriding •
• Équitation •
• Reiten •
• Верховая езда •

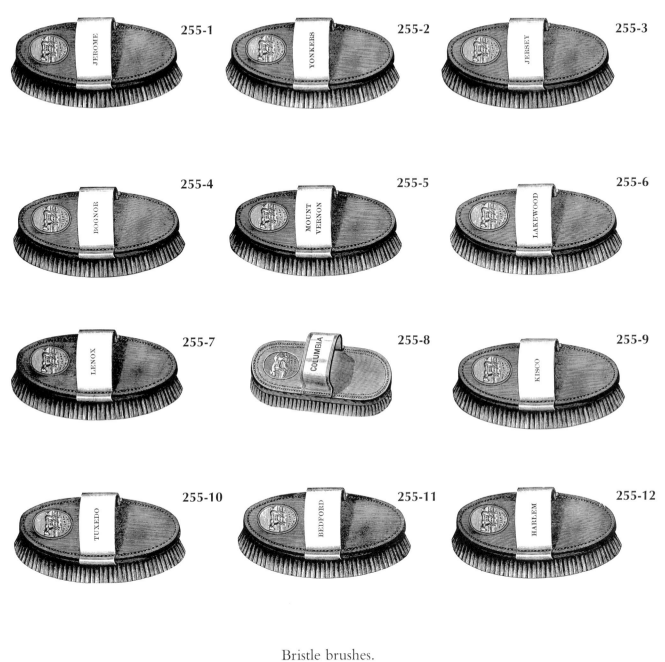

255-1 255-2 255-3
255-4 255-5 255-6
255-7 255-8 255-9
255-10 255-11 255-12

Bristle brushes.
Brosses.
Bürsten.
Щетинные щетки.

Moseman's Illustrated Guide for Purchasers of Horse Furnishing Goods, New York, n.d.

256-1

256-2

256-260:
Oils and dressings.
Bouteilles et boîtes de cirage.
Wachsflaschen und wachskartons.
Масла для ухода за лошадью. Банки с кремом.

256-3

256-4

Moseman's Illustrated Guide for Purchasers of Horse Furnishing Goods, New York, 1892.

256-5

256-6

257-1

257-2

257-3

257-4

257-5

257-6

258-1

258-2

258-3

258-4

258-5

258-6

259-1

259-2

259-3

259-4

259-5

259-6

260-1

260-3

260-4

260-5

260-2

260-6

261-1

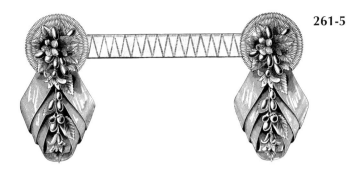

261-5

261-2

261-3

261-1, 261-4:
Straw mattings.
Équipement pour stalles.
Ausstattung für Stallbuchten.
Соломенные циновки.

261-5:
Harness ornaments.
Ornements pour harnais.
Verzierungen für Pferdegeschirr.
Узоры на сбруе.

261-4

Moseman's Illustrated Guide for Purchasers of Horse Furnishing Goods, New York, 1892.

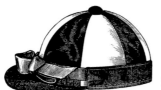 **262-1**

 262-2

 262-3

 262-4

262:
Drivers caps.
Casquettes de jockey.
Jockey Mützen.
Фуражки наездника.

Moseman's Illustrated Guide for Purchasers of Horse Furnishing Goods, New York, 1892.

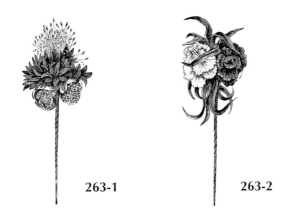

263-1 **263-2**

263-3 **263-4**

263:
Flowers for horses heads.
Fleurs pour têtes de chevaux.
Blumenverzierungen für Pferdeköpfe.
Цветы на голову лошади.

Moseman's Illustrated Guide for Purchasers of Horse Furnishing Goods, New York, 1892.

264-1

264-2

Rosettes.
Rosetten.
Розетки.

Moseman's Illustrated Guide for Purchasers of Horse Furnishing Goods, New York, 1892.

264-3

264-4

264-5

264-6

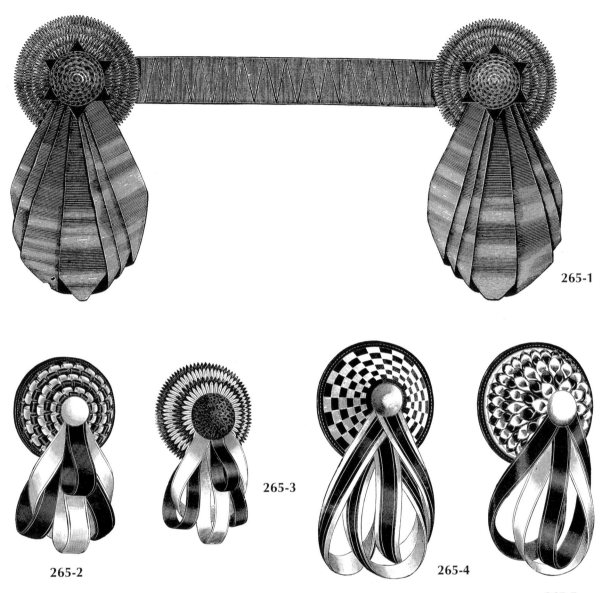

265-1

265-2

265-3

265-4

265-5

265–1:
Harness ornaments.
Ornements pour harnais.
Verzierungen für Pferdegeschirr.
Узоры на сбруе.

265–2, 265–5:
Rosettes.
Rosetten.
Розетки.

Moseman's Illustrated Guide for Purchasers of
Horse Furnishing Goods, New York, 1892.

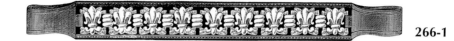 **266-1**

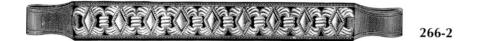 **266-2**

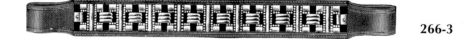 **266-3**

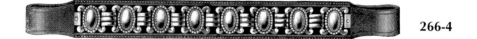 **266-4**

266–269:
Brodle fronts.
Brides.
Zügel.
Кнуты.

Moseman's Illustrated Guide for Purchasers of Horse Furnishing Goods, New York, 1892.

267-1

267-2

267-3

267-4

267-5

268-1

268-2

268-3

268-4

268-5

269-1

269-2

269-3

269-4

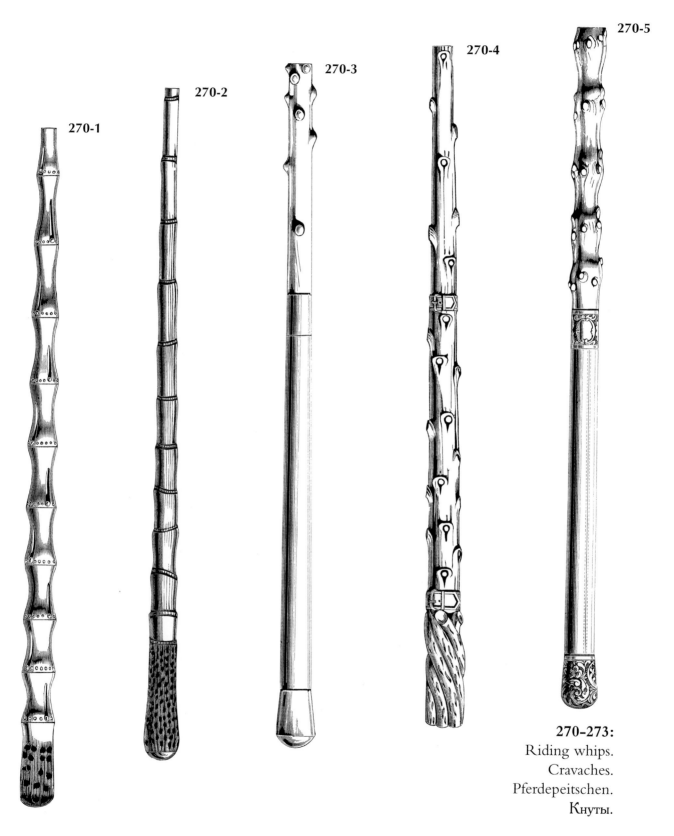

270-1

270-2

270-3

270-4

270-5

270–273:
Riding whips.
Cravaches.
Pferdepeitschen.
Кнуты.

Moseman's Illustrated Guide for Purchasers of Horse Furnishing Goods, New York, 1892.

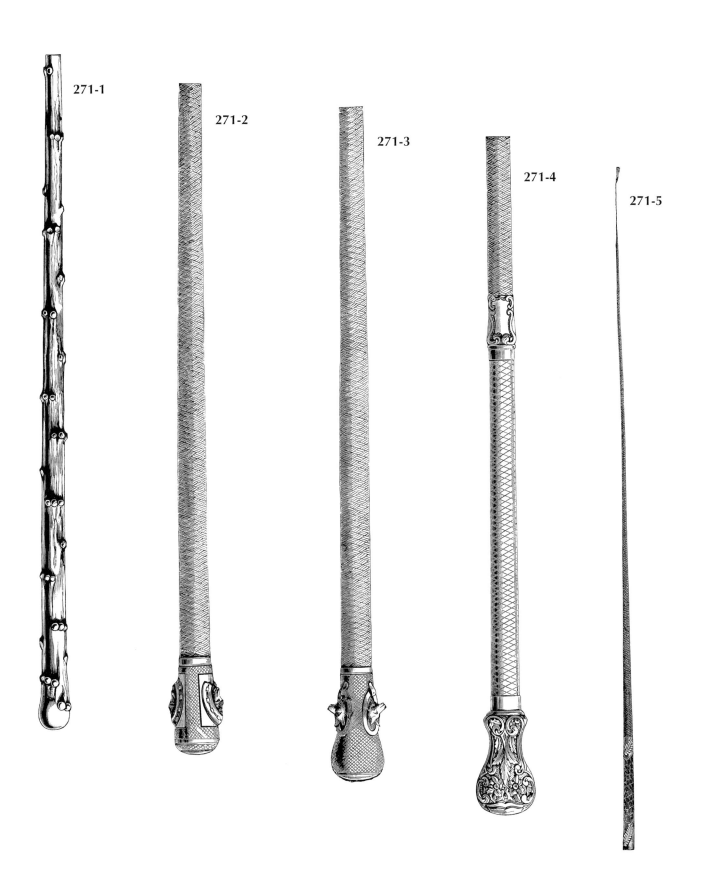

271-1

271-2

271-3

271-4

271-5

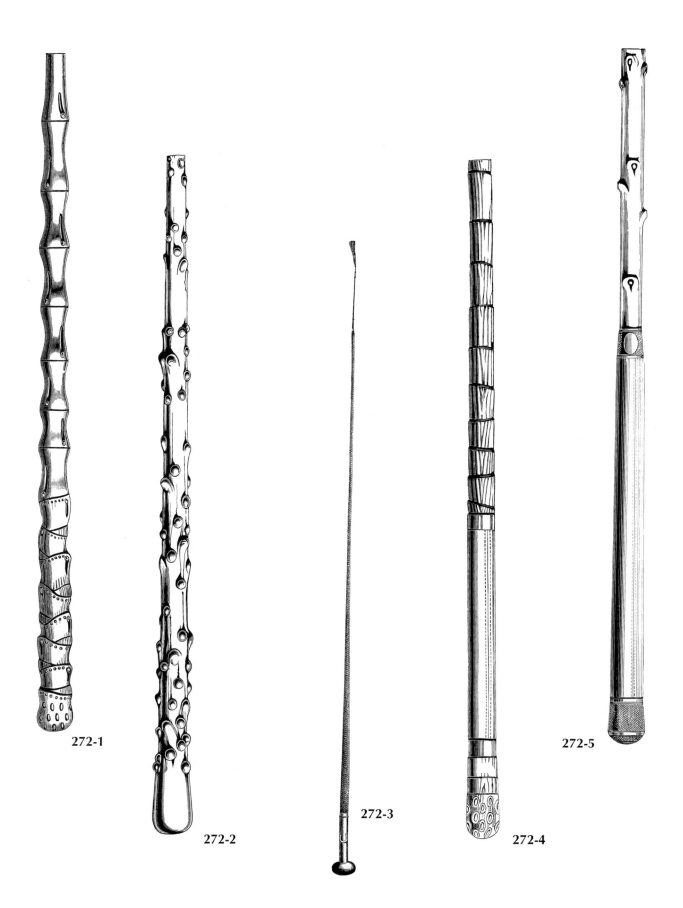

272-1

272-2

272-3

272-4

272-5

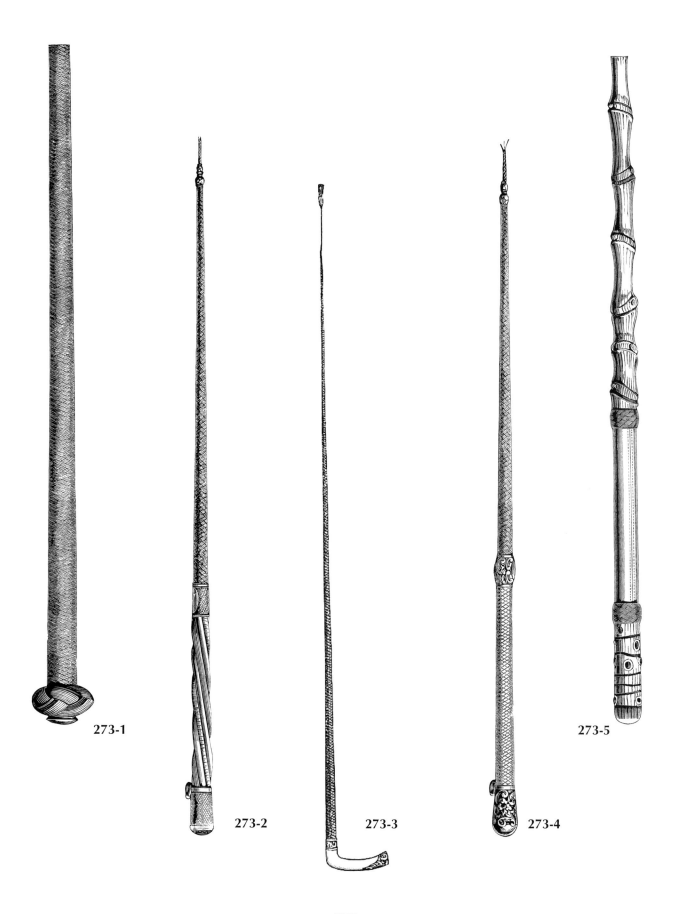

273-1

273-2

273-3

273-4

273-5

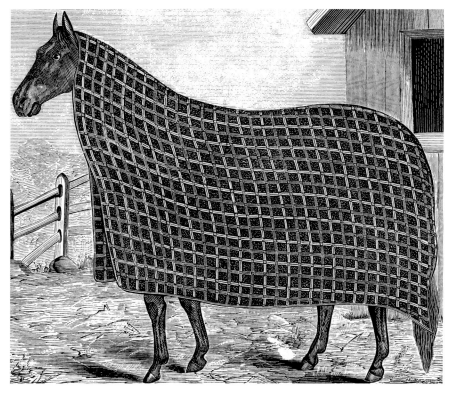

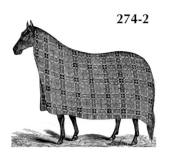

274-2

274-3

274–279:
Horses clothings.
Couvertures pour chevaux.
Decken für Pferde.
Попоны.

*Moseman's Illustrated Guide for Purchasers
of Horse Furnishing Goods,* New York, 1892.

275-1

275-2

275-3

275-4

276-1

276-2

276-3

276-4

276-5

277-1

277-2

277-3

277-4

278-1

278-2

278-3

278-4

278-5

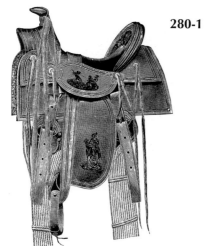

280-1

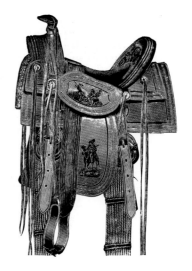

280-2

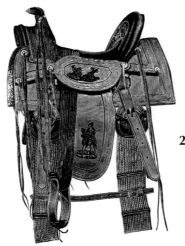

280-3

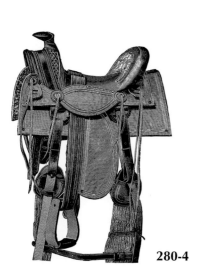

280-4

280–284:
Saddles.
Selles.
Sattel.
Седла.

Moseman's Illustrated Guide for Purchasers of Horse Furnishing Goods, New York, 1892.

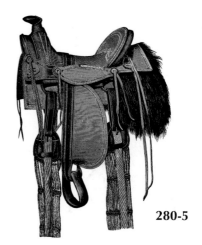

280-5

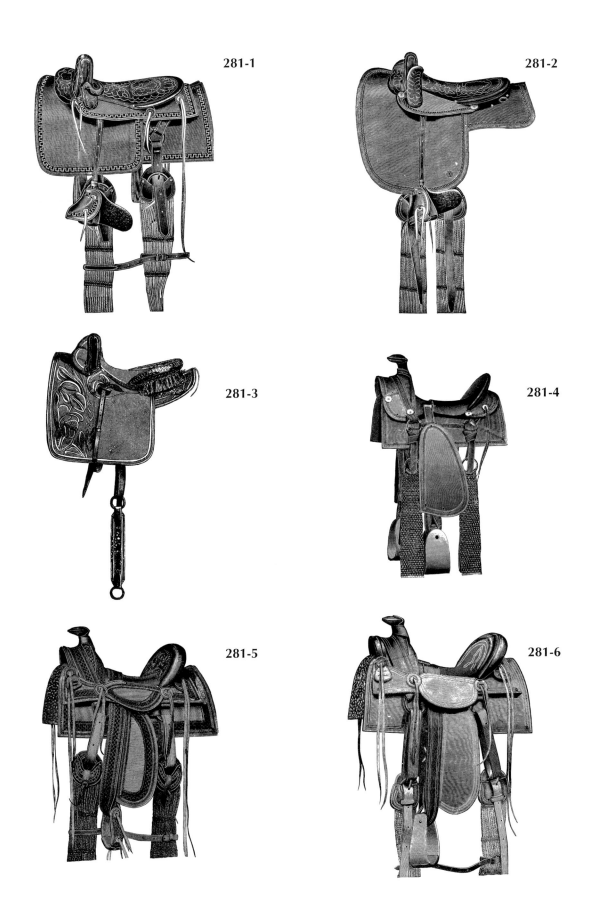

281-1

281-2

281-3

281-4

281-5

281-6

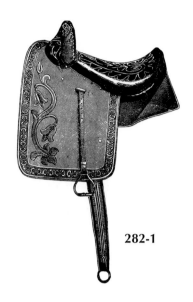

282-1

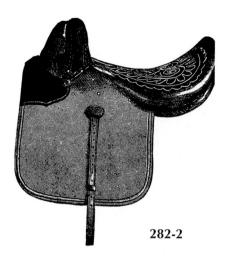

282-2

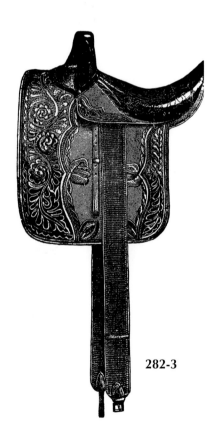

282-3

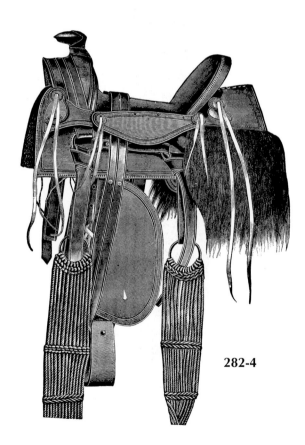

282-4

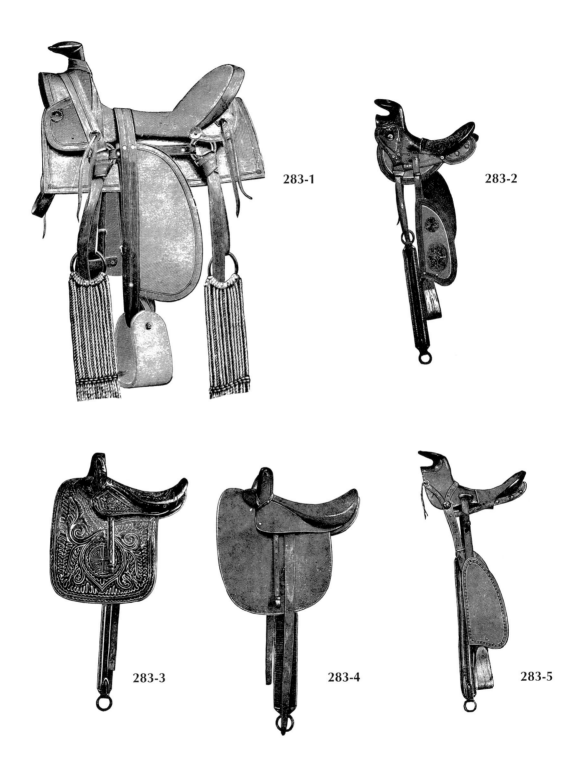

283-1

283-2

283-3

283-4

283-5

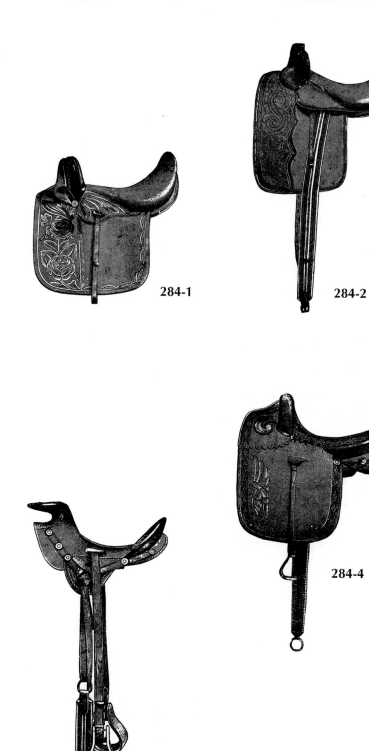

284-1

284-2

284-3

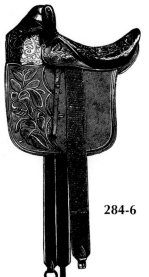

284-4

284-5

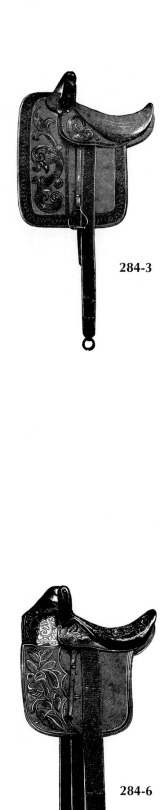

284-6

Floral Ornament
Ornement Floral
Blumen Ornamente
Ornamentación Floral
Цветочный Орнамент

L'Aventurine — Free CD-Rom for PC/Mac high resolution

Art Nouveau Ornament
Ornement Art nouveau
Jugendstil Ornamente
Ornamentación Arte nuevo
Арт Нуво Орнаменты

L'Aventurine — Free CD-Rom for PC/Mac high resolution

Ironwork • Fer forgé
Schmiedeeisen • Hierro forjado
Изделия из металла

L'Aventurine — Free CD-Rom for PC/Mac high resolution

Typographic Decoration
Décor typographique
Typographische Muster
Decoración tipográfica
Типографский декор

L'Aventurine — Free CD-Rom for PC/Mac high resolution

Alphabets
Alphabete
Alfabetos
Алфавиты

L'Aventurine — Free CD-Rom for PC/Mac high resolution

Egyptian Ornament
Ornement égyptien
Ägyptische Ornamente
Ornamentación egípcia
Егилетский орнамент

L'Aventurine

Furniture
Mobilier
Mobiliar
Mobiliario
Мебель

L'Aventurine

**Borders · Bordures
Borduren · Бордюры**

**Renaissance Ornaments · Ornements
Renaissance · Renaissance Ornamente
Орнаменты Ренессанса**

**Arabic Ornament · Ornement arabe
Ornamentación árabe · Arabische
Ornamente**

**Arabesques · Arabesken
Арабески**

**Costumes · Kostüme
КОСТЮМЫ**

**Fantastic Ornaments · Ornements
fantastiques · Fantastische Ornamente
Фантастический Орнамент**

**Japanese Ornament · Ornement
japonais · Japanische Ornamente
Японский Орнамент**

**Silhouettes · Schattenbilder
Силуэты**

Achevé d'imprimer en République tchèque en novembre 2007
Dépôt légal 4e trimestre 2007